POSTCARD HISTORY SERIES

Around Galeton and Coudersport

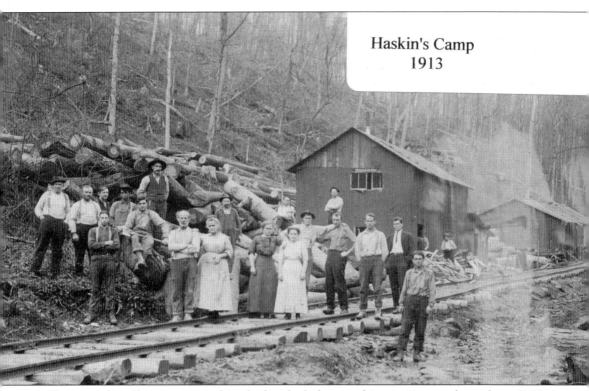

Haskin's Camp 1913

Scenes such as this were typical in the hemlock forests of Potter County from about 1885 to 1915. Camps of 20 to 100 wood hicks were located near the remaining trees, and railroads were built to take the logs to the mills that could saw over 250,000 board feet per day. As World War I came to an end, so did the virgin forests of Potter County.

On the front cover: This is the south side of Main Street in Galeton. The Rice and Cochran Store is located at the left. This business marketed groceries, fruits, and vegetables. The adjourning store is the C. P. Mosch dry goods, clothing, and shoe store. (Author's collection.)

On the back cover: This is a bird's-eye view of Coudersport looking north. Coudersport was surveyed and laid out in 1807 before there were any people living in the county. (Author's collection.)

Postcard History Series

Around Galeton and Coudersport

Ronald W. Dingle

Copyright © 2008 by Ronald W. Dingle
ISBN 978-0-7385-5719-9

Published by Arcadia Publishing
Charleston SC, Chicago IL, Portsmouth NH, San Francisco CA

Printed in the United States of America

Library of Congress Catalog Card Number: 2007941109

For all general information contact Arcadia Publishing at:
Telephone 843-853-2070
Fax 843-853-0044
E-mail sales@arcadiapublishing.com
For customer service and orders:
Toll-Free 1-888-313-2665

Visit us on the Internet at www.arcadiapublishing.com

Dedicated to the members and volunteers of the Potter County Historical Society. Without their expert assistance and access to the society's materials, the writing of this book would have been a monumental task and not a labor of love.

CONTENTS

Acknowledgments		6
Introduction		7
1.	Galeton	9
2.	Galeton's Railroads	39
3.	Original Coudersport	45
4.	Eulalia Village and Additions	55
5.	Austin	65
6.	Cross Fork	81
7.	Shinglehouse	93
8.	Germania	107
9.	Gold and Ulysses	113
10.	Other Towns and Villages	119
Bibliography		127

Acknowledgments

There are many people to thank for helping to make the publication of this book a reality. Thanks to the photographers of the early photograph postcard era, without whose work there could be no book. Thanks to the scholars and historians who have published previous works that preserved our early history for the current and future generations.

A very special thank-you goes to Robert Currin, curator of the Potter County Historical Society, for his expert assistance with historical facts, his ability to phrase these facts into enjoyable, informative reading, and for many long hours of his personal time to guide me through the society's archives. His love of history was my greatest motivation in putting this book together to share with current and future generations.

I would like to thank Henry Lush for the many hours he spent sharing his vast knowledge of Galeton.

Thanks also to Margaret Norton at the Oswayo Valley Historical Society for helping with Shinglehouse information.

Thanks to Ronald Dean Sr. and Erma Evans for their help with Galeton information.

A thank-you to all my friends and new acquaintances in the towns of Potter County who shared their knowledge of the past to help make the captions contained in this book more informative.

Thanks to Erin Vosgien and the Arcadia Publishing staff for their help with this project.

Finally, I could not have completed this large project without the support and motivation of my friends and family, especially my amazing and loving wife, Sandy. Thanks everyone, I hope I met your expectations.

A portion of the proceeds from the sale of this book are being donated to the Potter County Historical Society.

Unless otherwise noted, all postcards used for the publication of this book are from the author's private collection.

Introduction

Potter County is headwater country, the starting point for three river systems. The land is somewhat higher than surrounding areas, thus the waters flow northward, westward, and southward. Steep hills and narrow valleys dominate the landscape, which perhaps kept early pioneers away. Neighboring counties were settled almost a decade before activity began here. Twenty years after the land was purchased from the Iroquois in 1784, there were no clearings inside the borders, causing some to refer to this highland as "Pennsylvania's last frontier." Pennsylvania sold over a million acres of this land to William Bingham in 1792. Four years later, Bingham in turn sold 300,000 acres of it to John Keating, whose Ceres Land Company brought the first people to open the county.

In 1804, the Pennsylvania legislature passed bill 49 that divided the 1784 purchase into seven new counties. Potter County was taken from Lycoming County and for a few years was attached to this mother county as part of Dunnstable Township. In 1810, the entire county became Eulalia Township, which was named to honor the wife of John Keating.

The first permanent settler, William Ayers, came in 1807 and settled in the eastern part of present Homer Township. He was followed in 1810 by Isaac Lyman, who had charge of building the east–west road. Lyman was the first to locate in present-day Coudersport at what he called Lymansville, presently Ladona. The first census was taken in the county that year and counted 29 residents living in the two locations. Ten years later, the population was six times larger, but still, only 186 were counted.

Most of the early settlers came from New England and New York. For some, this was a stop on their migration route westward, but the local area accommodated many of these migrants to the present. In 1848, Coudersport was organized as the county's first borough. Lewisville followed in 1869. Villages grew, but it was not until 1885 that Austin was organized, followed by Galeton in 1896. Sawmills and allied industries built both of these. Shinglehouse and Oswayo in the Oswayo Valley were incorporated in the early 20th century.

The population of the county had increased from 186 in 1820 to 1,265 in 1830, and settlement was still moving forward. Schools, gristmills, churches, stores, and so on were all being erected, as needed by the settlers. Some sawmills were built and lumbering was beginning to assume some importance as an industry. Potter County was still in the backwoods but was well started on the way out.

No Potter County village or borough ever came close to city status. Galeton came closest in 1910, with 4,000 residents. The county reached its population peak at 30,621 in 1900, but as the virgin timber was cut very rapidly, the woodsmen began to move on to exploit new forests.

By 1930, only 17,501 were enumerated and the population began to even out. Over the last 80 years, it has remained within about 1,000 of the 1930 count.

Few, besides farmers, lived here until 1885, when the big sawmills and the railroads began to provide employment. The dominating forests soon began to disappear, as they provided the raw material for the greatest period of industrial activity in Potter County's history. Millions of logs were cut between 1885 and 1920, and the forests that had stood in the way of the early farmers were now decimated. Some referred to the county as a desert.

Almost two centuries ago, in 1810, the first sawmill was built in Potter County, and by that time, the streams had been declared public highways. The streams served their purpose for about seven decades. Rafting was developed where streams were large enough. Pine Creek from near Galeton and the Sinnemahoning Creek from Costello both sent many rafts to the Susquehanna River and on to the Chesapeake Bay. This method took much of the timber from along the larger streams to market, but the headwater country was not cut.

In 1847, log booms were placed in the river at Williamsport and nearby towns to collect logs to be sawn at local mills. Williamsport had 37 mills and became the lumber capitol of the world by 1860. Using splash dams, another section of the forests were harvested and marketed, but thousands of acres were left for another transporter.

The railroads took over the task. They could be built back into the forests and then main line roads could take the lumber to the markets. Demand for lumber was increasing and European immigrants were moving into the Midwest and building town and city dwellings of wood. It was up to the rural areas such as ours to supply lumber. Potter County had hemlock trees that were frowned upon by earlier loggers and carpenters, but a few changes in technology and need made the once-forlorn tree look good, especially to a few absentee landlords who could find the money to invest.

Railroads had been used in a few areas previously but not to the extent they were to be used here. The new mills had capacities of several hundred thousand board feet per day. Hundreds, even thousands, of wood hicks looking for work invaded the county. Logging camps dotted the hemlock forests and many villages sprung up. Farms flourished along with many other enterprises.

This was a great time for a new quick way to communicate with loved ones. The rural delivery was in its infancy and post offices dotted the forests. Some of the lumber camps had their own post office. It was a great time for the "picture postal card" to emerge.

Photographers had been using card or paper material as a medium for years, but now they saw the need for a method to get hard-working people to be able to send short messages cheaply. The penny stamp made it cheap and the picture became part of the message. The picture was usually identified, so all the busy woodsman had to write was, "This is where I am."

The picture postcards in this book will take the reader on a trip from the very early 20th century into the 1950s. It is through the camera lenses of the great photographers that we are able to view how the county's founders lived, worked, and played.

One

GALETON

If one takes a ride today throughout north central Pennsylvania and Potter County in particular, one would find very little to indicate that the area has not always been a glorious destination point for a peaceful vacation of hunting and fishing.

Galeton's history had a late start compared to some other Potter County towns. The county was originally settled from the north, starting about 1804 in the Ceres and Shinglehouse areas. Settlement also started about 25 miles north of Galeton in the northern areas of Ulysses and the Cowanesque Valley, as the land was better suited for farming.

The Pine Creek Valley was thickly covered with pine and hemlock forests and there were no roads up the narrow valley. Because of this, the people settling further to the north overlooked the Galeton area. The first settlers in the Galeton area came around 1810 to 1815. Some of the first people to settle in this area were Samuel Losey, who lived on a farm east of town. John Ives, a soldier in the Revolutionary War, settled somewhere near the present location of Galeton. Another early settler was John Phoenix, who located near the mouth of the present-day Phoenix Run.

The Galeton area was known as Pike Mills in 1825, and about 1830, it became known as Pike Center.

Who would ever guess that only a little over 100 years ago, the major portion of lumber and leather used in the United States came from this area of Pennsylvania, leaving the now-beautiful mountains a vast wasteland. In traveling to Galeton at that time, one would have found logging camps throughout the mountains, with wood hicks cutting the timber and skidding the logs to small, local sawmills or creek side for the spring log drive to the Williamsport Mills. Before Frank and Charles Goodyear came to Galeton, Potter County's logs helped make Williamsport the lumber capital of the world. Once they arrived on the lumber scene in 1894, they bought the Clinton Mill and put their own crews and logging railroads into the mountains. These railroads brought the logs to their mills to be sawed locally and not floated to Williamsport via the creeks and river. They operated a three blade band-style sawmill in Galeton that is said to have been the largest mill producing hemlock lumber in the country at the time.

In addition to a kindling wood factory, other large industries associated with the lumber industry were chemical plants, hub factories, and stave and heading mills. The town of Galeton had all of these plus many smaller industries.

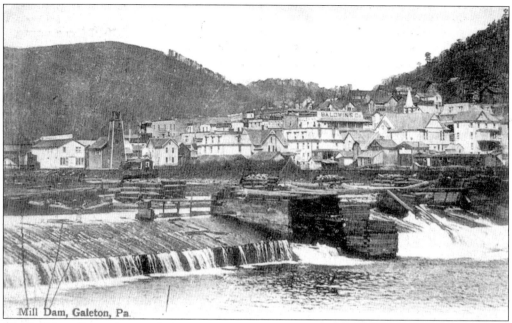

The milldam directed water from Pine Creek to the Goodyear Hemlock Mill Log Pond. In the left background is the Gale Hose No. 1 building along with other buildings on Bridge Street and the business section of town. This picture was probably taken a short time before 1900. The dam was located about where the tennis courts are today.

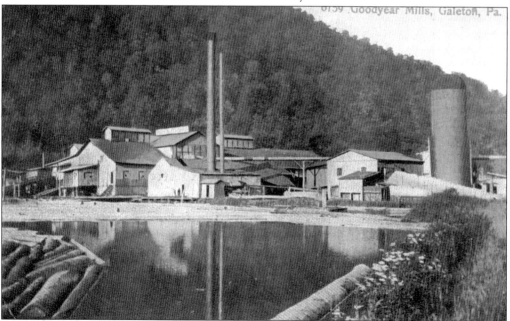

This is the Goodyear Hemlock Mill that was bought by Frank and Charles Goodyear from the Clintons in the spring of 1895. It was located where Galeton Area School is today and was one of the largest sawmills in the United States. The mill was painted and lighted with electricity, which was very unusual for the time. They piped live steam into their log pond to keep it from freezing in winter.

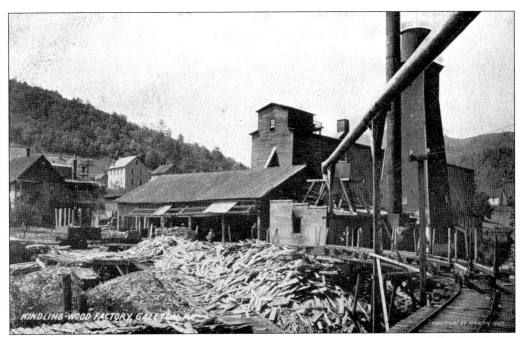

The Kindling Wood Factory at Galeton was built in 1895 and operated by the Pennsylvania Wood Company. Wood for the operation came from across Pine Creek on a conveyor from the Goodyear Hemlock Mill. Their main products were lath and bundles of kindling wood.

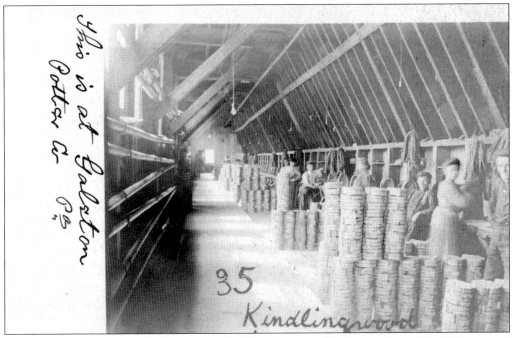

This is an extremely rare real-photo postcard of the top floor of the Pennsylvania Wood Company's Kindling Wood Factory. Shown are women and children bundling the firewood for shipment to some large city in the east, most likely New York City. The wood was dried on one of the lower floors before reaching the top floor to be bundled.

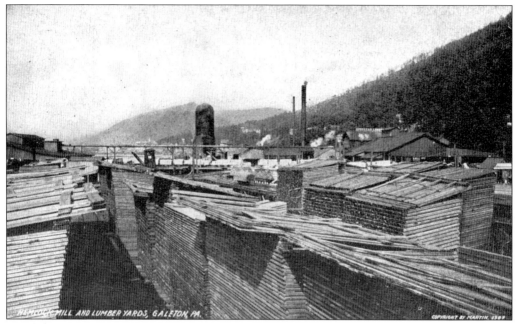

The Goodyear Hemlock Mill lumberyard was located east of the mill. The sawed lumber was usually stacked 22 feet high, 11 feet below and above the platform carrying the sawed lumber delivery buggies from the mill. The mill was located at the present site of the Galeton Area School.

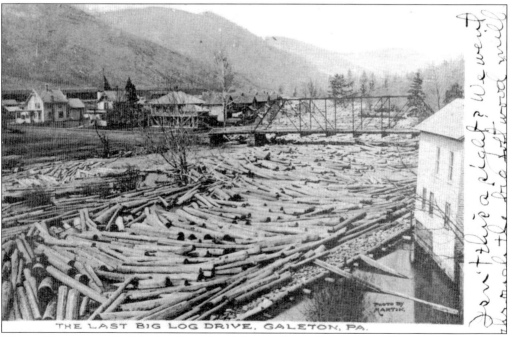

Pictured is a postcard of the last large log drive to the Williamsport mills out of the Galeton area. After this, most all the logs were cut in local sawmills. These log drives were always in the spring, when water was at its highest. In the background, the Lorin and George Gale homes along Bridge Street can be seen.

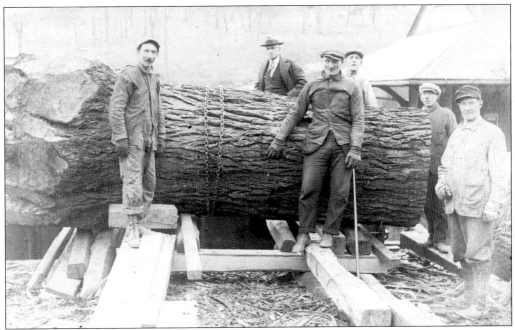

This very large white pine log was probably on its way to the Goodyear Hemlock Mill in Galeton. Judging by the height of the men, it appears to be about five feet across at the stump end. It must have been of record size to be documented with a postcard.

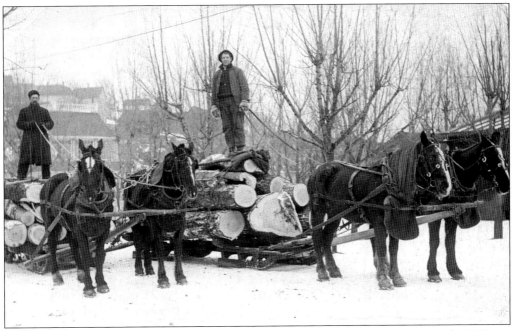

Shown here is one of the many methods used to haul logs to the mills in the early 1900s in Potter County. These men may have been local gentleman working for one of the mills, farmers, or private landowners harvesting and hauling their own logs. This is a seldom seen real-photo postcard taken in the winter, as the logs are on sleds.

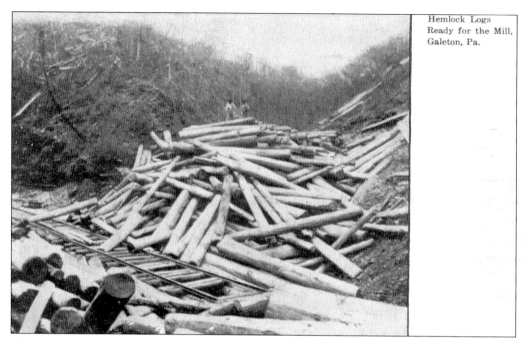

Hemlock Logs Ready for the Mill, Galeton, Pa.

This postcard shows a very good example of a rough-and-tumble log pile in the mountains. This method of piling the logs along the tracks was used after the log loaders came on the scene. It was preferred over having the wood hicks roll the logs onto the railroad cars with pike poles and cant hooks. The logs had to be neatly stacked for hand loading by the wood hicks.

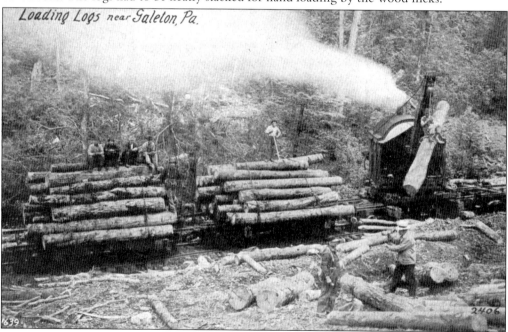

Loading Logs near Galeton, Pa.

This is an example of a typical logging scene in the mountains around Galeton in the early 1900s. This appears to be a Barnhart Loader at work. Loading the train cars with logs became safer when these log loaders came on the scene. From the size of the logs it probably indicates the logging era was about to come to an end.

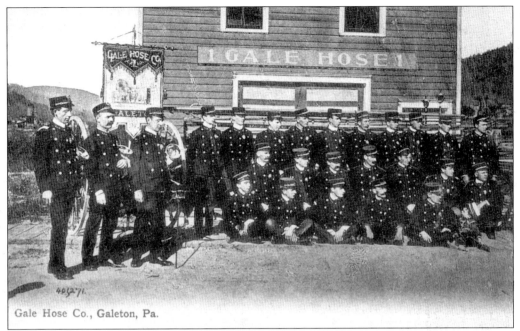

Gale Hose Co., Galeton, Pa.

In 1897, the Gale Hose Fire Company was organized. The firehouse pictured here was probably built in the very early 1900s. It burnt in the big fire of 1916 and was never rebuilt. The old firehouse on Sherman Street in Clintontown was used until it was replaced with a new building in 1971 and is still in use today.

The Gale Hose running team is shown here in the early 1900s. From left to right are (first row) F. E. Raymer, Alec Brewster, Bert Gridley, Royden Egler, Tom Riley, Bub Zong, and John Bierman; (second row) Olin Brewster, John Tomko, Frank Lowe, Fred Schrade, Bill Doyle, Harry Moran, Jay Ellsworth, Bill Saxe, Jay Moran, unidentified, Gus Bergreen, Irvin Yahn, and Dick Satterly.

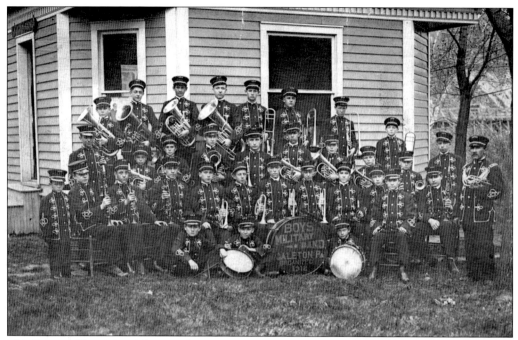

The Boys Military Band from Galeton was organized in 1912. The picture was taken in front of the band house, which was erected in 1910. It was located at the end of the bridge on West Street at the time. In the row behind the drum row, the sixth person from the left is Gale Lush, who was born in 1897.

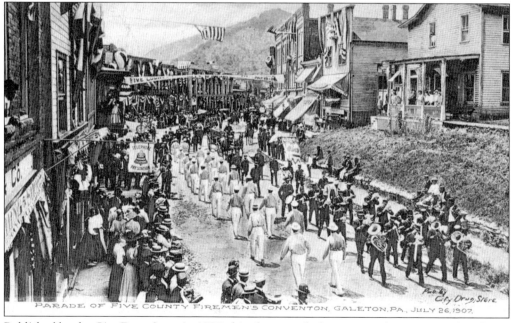

Published by the City Drug Store in 1907, this photograph shows a parade view not often found on a postcard. The marchers are going in two different directions as a countermarch was in progress in order for the parade to end at the point where it began. The parade was part of the five county fireman's convention held in Galeton in 1907.

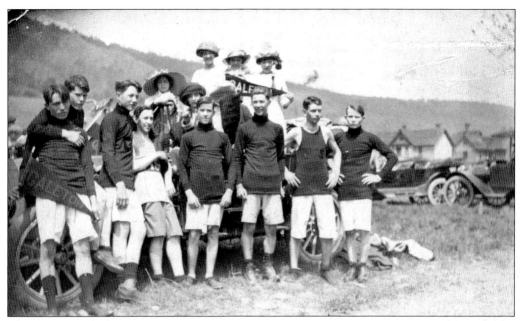

This is a real-photo postcard of the 1913 boy's basketball team from Galeton Area School. Galeton has always been noted for its winning basketball teams. Did the team have cheerleaders in 1913? The boys probably had girlfriends.

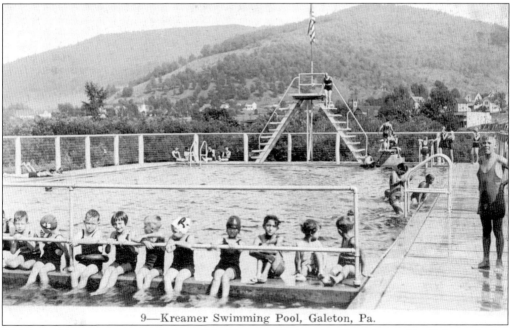

9—Kreamer Swimming Pool, Galeton, Pa.

This is a seldom-seen postcard view of the Kreamer Swimming Pool, located in Galeton during the early 1930s. It was built about 1930 and closed about 1936. It had a child's pool and an adult pool with diving platforms. The depth at the diving area was 10 to 12 feet. Water was piped into the pool from the tannery well.

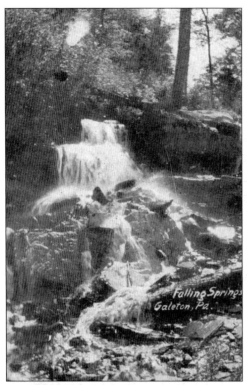

Falling Springs is located on the south side of Pine Creek just west of Galeton. It has been reported that a log slide located in this area shot logs into Pine Creek. When one of the logs came out of the slide, it wrapped around a tree with a wood hick behind it for protection and killed him instantly.

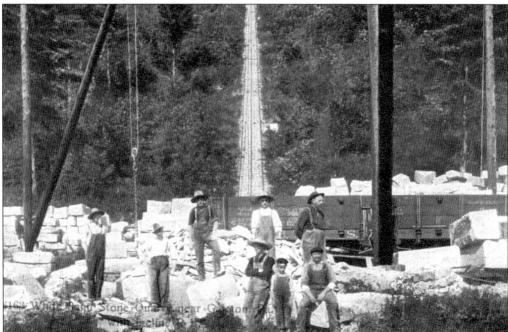

The White Sandstone Quarry was located on the mountain west of Galeton. It had an incline railroad to bring the huge stones down the mountainside to load on railroad cars for shipment. Some of the stone was used for building foundations in the area and the large Pennsylvania Railroad bridge across the river north of Harrisburg.

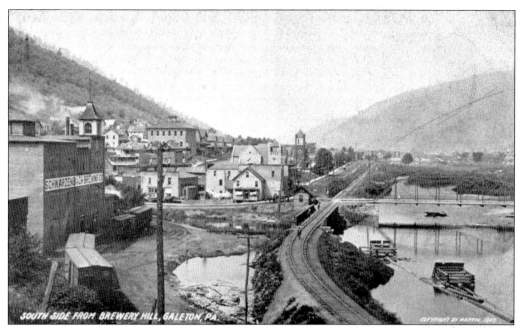

This photograph view of Southside from Brewery Hill was taken about 1907. The brewery building can be seen on the left. The old schoolhouse located on the hill behind the churches operated until the mid-1950s. Also visible are the Buffalo and Susquehanna Railroad tracks leading to the yards at the west end of town and the Bridge Street bridge over Pine Creek.

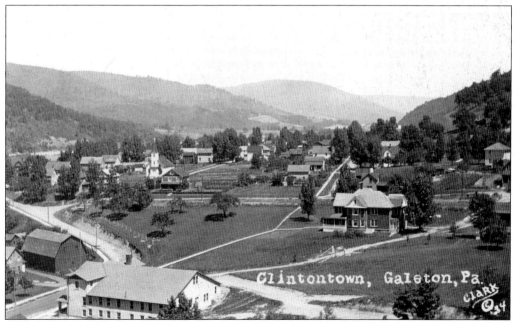

This is a George Clark photograph of Clintontown in 1925. The Galeton Community Building can be seen in the foreground and the Devling home is to the right center. The Clintontown area was still underdeveloped 25 years into the 20th century.

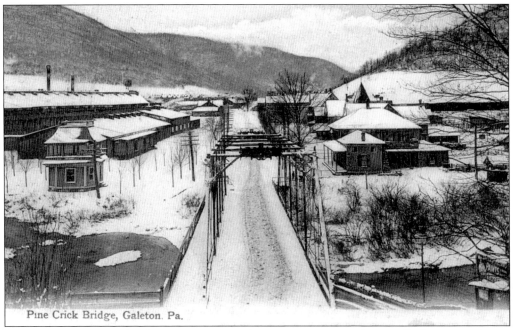

Pine Crick Bridge, Galeton. Pa.

Shown here is the iron bridge on West Street that crosses Pine Creek just off of Route 6. Across the bridge on the left is the band house long before it was moved and renovated. One of the first houses built in Galeton is the first building on the right. It was built by Maj. John Kilbourn and included a tavern and rooming house.

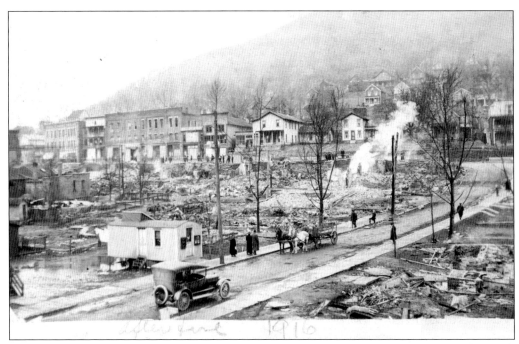

A real-photo postcard view shows the big fire of January 19, 1916, that burned most of the south side of Main Street and both sides of Bridge Street. Smoke was still visible coming from the ashes when this photograph was taken. It was the worst fire disaster to ever hit Galeton.

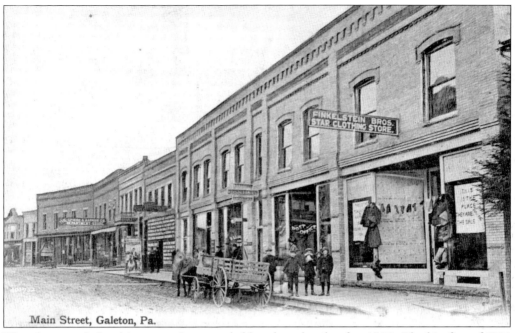

Main Street, Galeton, Pa.

The photograph for this postcard was probably taken shortly after 1900. The big fire of 1916 that wiped out most of the south side of Main Street and both sides of Bridge Street started in the Finkelstine Brothers Star Clothing Store. It was reported at the time that the company was thawing out some frozen pipes. It was the largest fire ever in Potter County.

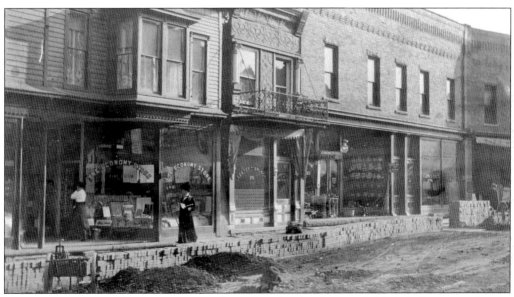

This is a great view of the changing times for Galeton's Main Street. Visible is the large, continuous pile of bricks, which brought Main Street out of the mud and dust and into the future with a very nice, brick-paved street. It took about 100 men to do the job. This photograph was taken in 1913.

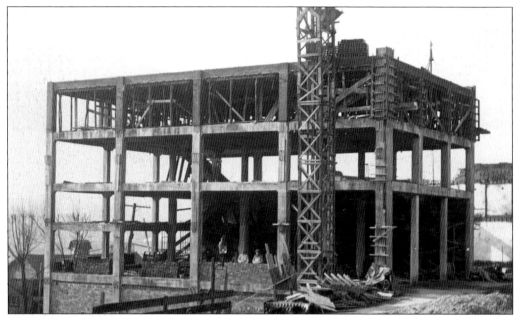

This is the new Horn and Develing Hardware building rising from the ashes after the January 19, 1916, fire that destroyed a large part of the southeast side of Main Street and most of Bridge Street in Galeton. The weight of the concrete and reinforcements used in construction was 136,000 tons. The weight of the building after completion was 225,000 tons. The approximate cost to rebuild was $50,000.

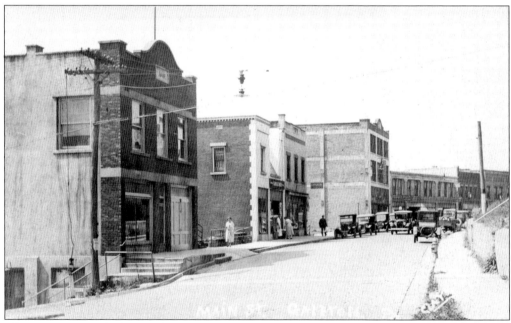

This is a George Clark real-photo postcard view of Main Street in Galeton in the early part of the 20th century. From left to right are the borough building, Grand Union Store, drugstore, and the hardware store. From the amount of cars on Main Street, it appears that the days of the horse-and-buggy were beginning to fade.

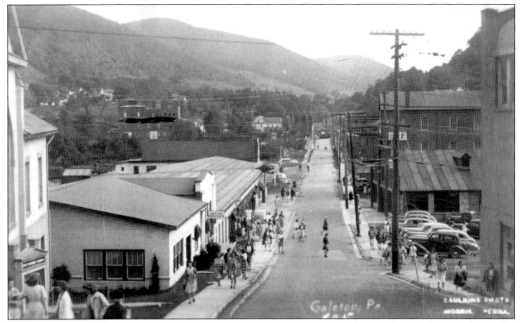

At one time, the Galeton Production Company, located on Bridge Street in Galeton, was the largest industry in Potter County, employing over 600 people. The main product manufactured at the plant was tubes for Sylvania. During the war, it made proximity bomb fuzes. After the war was over, its main product was radio tubes.

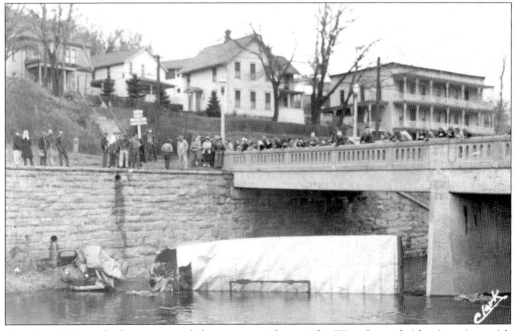

Another Clark real-photo postcard shows an accident at the West Street bridge junction with Route 6 toward the west side of Galeton. The accident resulted in a tractor trailer truck lying in Pine Creek. It happened on March 5, 1949. The driver of the truck had to swerve to avoid hitting a car. It was hauling a load of castings at the time.

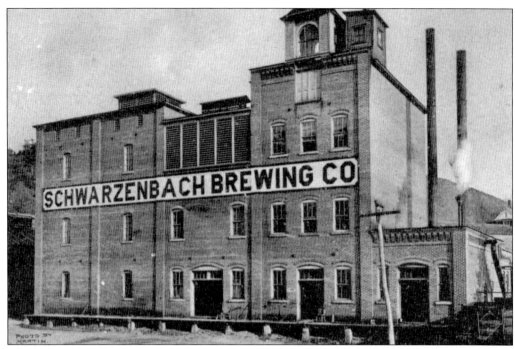

Joseph Schwarzenbach founded the Schwarzenbach Brewing Company at Germania in 1857. He died in 1892, and the business was taken over by his three sons, Roland, Herman, and James. About 1902, the company built a new plant in Galeton just below where the South Branch enters Pine Creek. Although the brewery is gone, the home that was erected along the shores of the South Branch is still occupied.

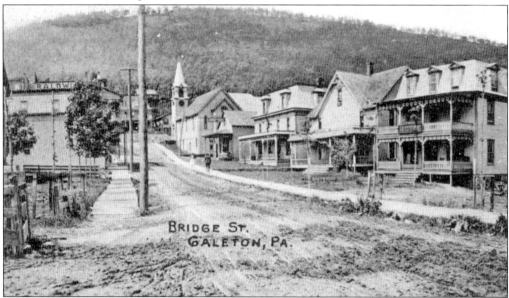

Looking from south to north, this seldom-seen postcard view shows Bridge Street in Galeton. There are many large buildings visible on the right, starting with a three-story hotel, a number of houses, and the church on the corner along Main Street. This photograph was probably taken around 1900.

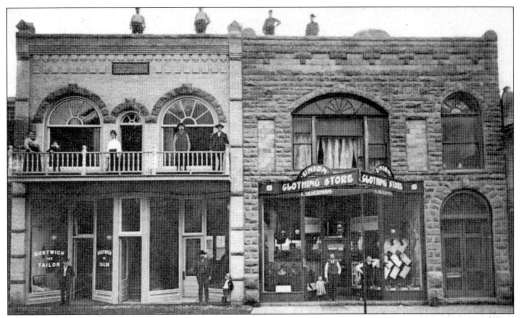

This great view of two storefronts in Galeton was taken about 1907 or 1908. The Gustwich Tailor Shop and the Silverman Clothing Store were located on the south side of Main Street across from where the Sunoco Station was in later years. Note how the photographer posed people in front of and even on the roof of the building.

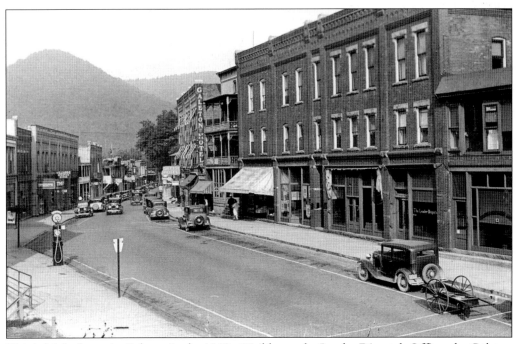

This is Main Street in Galeton in the 1940s. Visible are the Leader Dispatch Office, the Galeton Hotel, the Billiard's and Sporting Goods building, and the theater where one had to go down the steps after entering from Main Street to get to the balcony. The street sweepers cart can be seen at the bottom right.

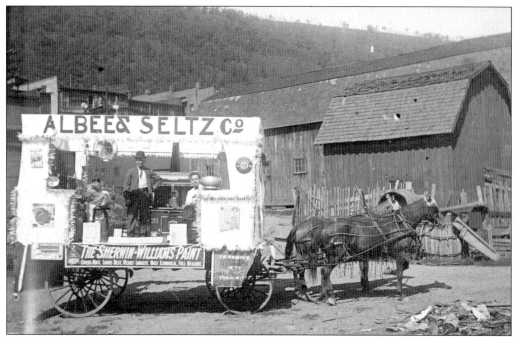

This is a real-photo postcard of the Albee and Seltz Company float entered in the 1925 Labor Day parade in Galeton. Two of the signs on the float advertise Sherwin-Williams Paint and Blasting Powder for stump removal. The picture was taken behind and below the Main Street buildings.

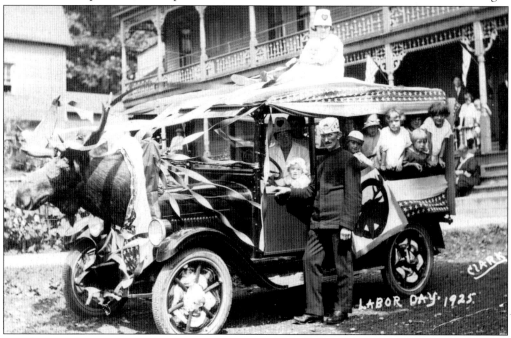

Parades were big events in the early 1900s in Potter County. People came from nearby towns on all available means of transportation. This George Clark real-photo postcard of the Moose lodge float entered in the 1925 Labor Day parade in Galeton was taken in front of the Edgecomb Hotel along Main Street.

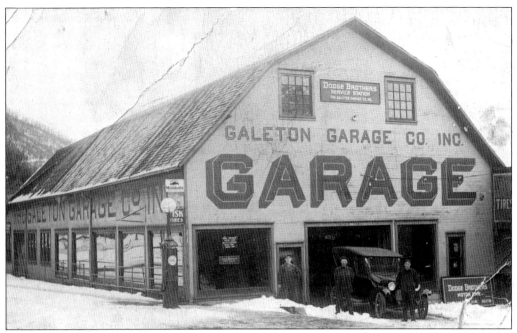

The Dodge Brothers Service Station was located in Galeton. The building was located on the former site of the Edgecomb Hotel horse barn at the east end of town. Later another garage and car dealership at this site was owned by Frank Osgood and then by his grandson Frank Evans and served the residents of Galeton and the surrounding area for many years.

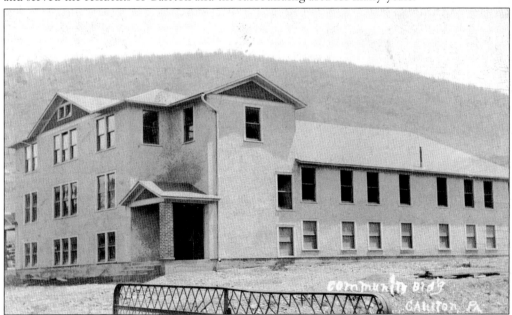

The community building in Galeton was built about 1925 by the American Legion. In its later years, the Rotary Club refurbished it. In more recent years, the Gale Foundation gave money for the metal roof that now covers the building. This building has served the community well through the years, being used by the churches, schools, and service clubs, along with departments of borough operations.

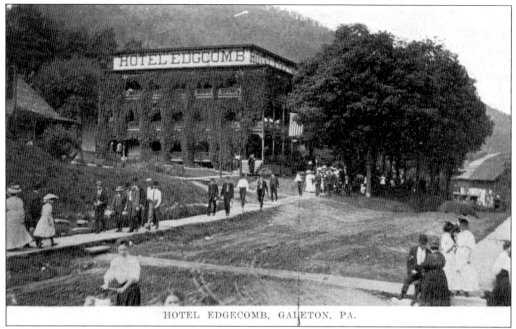

The Edgecomb Hotel was a vine-covered building in 1909. With all these people pictured, this could have been a special event, but was most likely a Sunday around dinnertime, as this hotel was very famous for its excellent food. In the distance on the right side of the card is the hotel's horse barn, located where the Osgood Garage was later built.

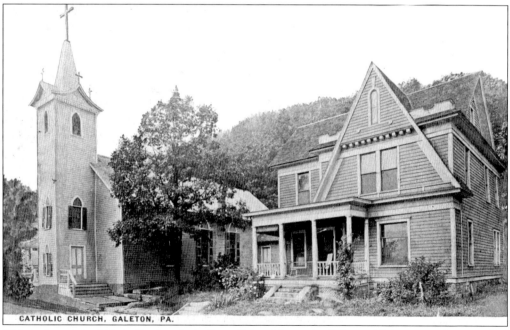

This is the original Catholic church, built on School Street in Galeton. This postcard was mailed in 1926. The Gale family, who came to town and built the tannery, gave money to help build this church so that their employee's would have a place to worship. It was just recently torn down to make way for another dwelling.

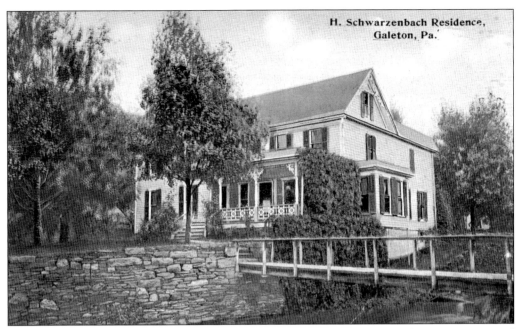

The Herman Schwarzenbach residence was built around the same time the brewery was moved from Germania to Galeton. It is located on the east bank of the South Branch of Pine Creek, south of the present Route 144 bridge. This house is now the well-maintained private residence of Richard Yonkin Jr.

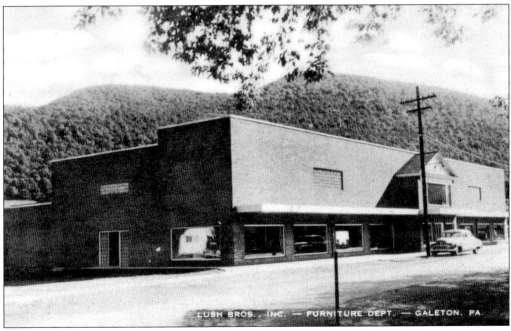

This is a postcard view of the Lush Brothers furniture store located at West Street in Galeton. Samuel Lynn Lush erected the building in 1949 and 1950 at a cost of $34,000. The 1950 Super Buick parked in front of the store belonged to William Gale Lush. Henry Lush can remember carrying bricks during the construction of the building as a young man.

The Hotel Waldorf, better known as Dan Shine's, is pictured in this seldom-seen real-photo postcard from the early 1900s. This establishment was located next door and north of the Hotel Columbus on West Street. One had to be careful when exiting the building, as the sidewalk was very narrow and traffic passed nearby on the road.

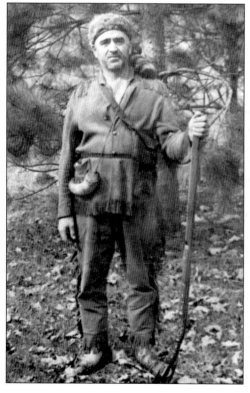

Joe Close, who was Galeton's mayor from about 1968 or 1969 to 1980, is dressed for a parade. The town residents thought very highly of Close, as he moved the town forward in a very productive manner. He was also the owner of the Club 61 Hotel located at 61 Germania Street. He had one of the finest deer antler and gun collections in the area.

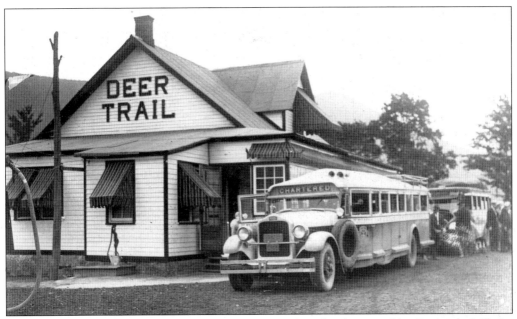

During the late 1940s and the 1950s, this business was owned and operated by George and Gladys Deitrich and Clarence and Alice Detar. It was well known throughout the area for its fine food. The bus in the foreground appears to be from the 1930s. In recent times, Jim Verbjar operated a Christmas shop in the building for a number of years.

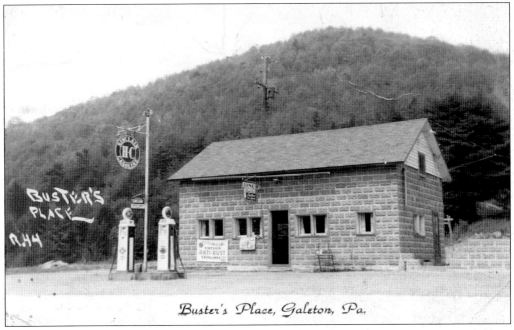

Buster's Gas Station and Luncheonette was located west of Galeton along Route 6. Buster Grant operated the business in the 1950s and into the 1960s. Sam Houston bought the business and operated it from about 1974 to 1989. In addition to the convenience store, Houston also sold cars while he owned the business. The building is currently empty.

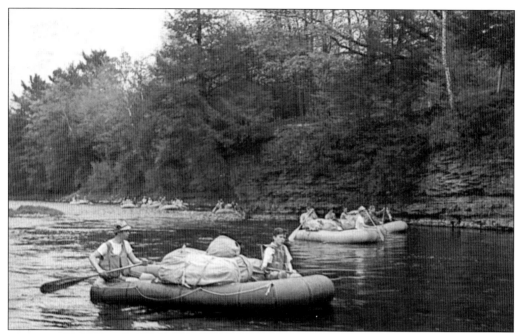

Edward McCarthy started a rafting operation in 1957. Although his business was not located in Potter County, some of his launch sites were. For his inaugural trip in the spring of 1957, he took the Galeton Chamber of Commerce on a float trip from Galeton to Ansonia. His trips through the Pennsylvania Grand Canyon were big favorites. He gained national attention when a magazine published a picture of him in one of his canoes on its cover.

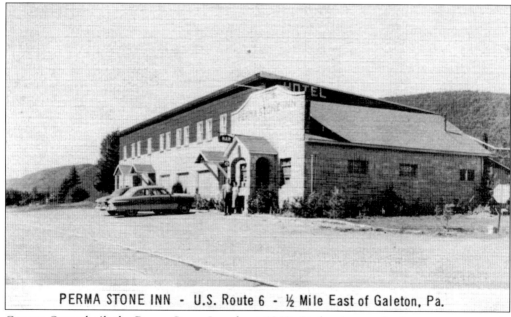

PERMA STONE INN - U.S. Route 6 - ½ Mile East of Galeton, Pa.

George Owen built the Perma Stone Inn about 1940. At the time, only the one-story part in the right of the picture was erected. In 1947 and 1948, Vern Beacker added the two-story piece on the west end toward Galeton. It contained a large, spacious room downstairs for dining and meetings and a number of guest rooms on the second floor. It is still in operation today.

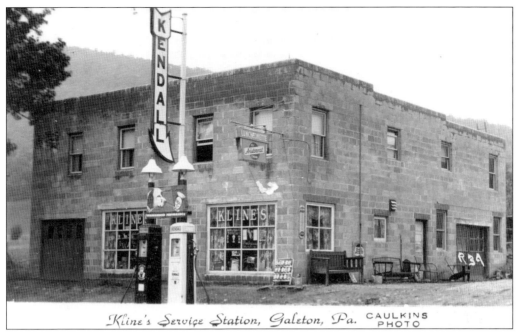

Elmer and Olive Kline began their business in this building in 1946. It started as a gas station, and later a gift shop was added. The business burned down in 1990 and was rebuilt as a one-story building, housing a large gift shop. It is now owned and operated by their daughter Mary Bowles and is the oldest gift shop operating in Potter County.

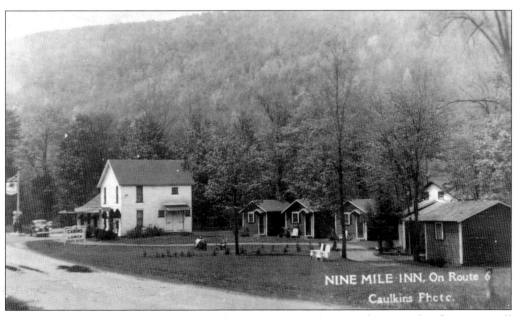

This is an early postcard of the Nine Mile Inn Tourist Cabins on the east side of Denton Hill along Route 6. It has had numerous owners, including Howard Byers and Harold Stutzman. Since 1969, Ralph Wentz has operated the business. Since this picture was taken, the cabins have been moved and a large pond was built in front of them.

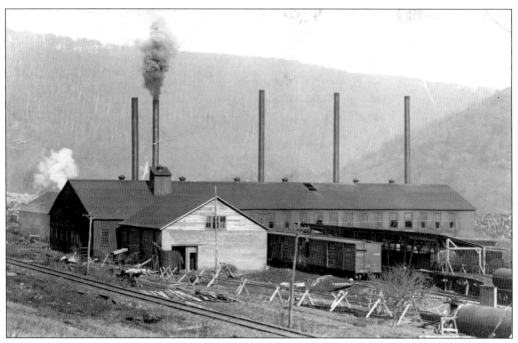

As the logging activity in Potter County began to decrease, many of the leftover trees were used to produce charcoal and chemicals. This plant was located near the mouth of Lyman Run and was operated by the Gaffney brothers, who also had a larger facility at Walton.

In the early 1900s, there were many types of postcards on the market. This postcard gives some insight into the sense of humor possessed by the forefathers of the country at the beginning of the 20th century.

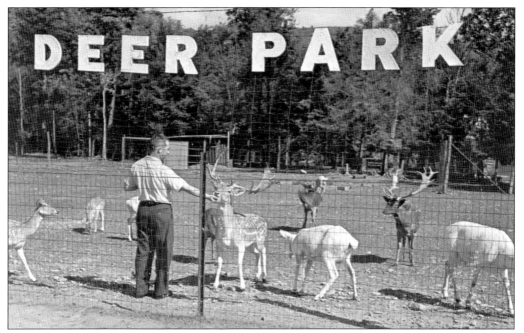

Deer Park was started around 1953 as a tourist attraction. Bill Lehman, who was the third owner, is pictured feeding the deer. In 1981, he sold the business to the present owner, James Verbjar. Verbjar has owned this very popular area attraction longer than any of the previous owners. It is known as the Black Forest Trading Post and Deer Park.

Although this George Clark picture was taken over the Potter County line in Tioga County, it indicates how good the deer hunting was in the area in the 1950s, 1960s and the early 1970s. During those years, Potter County led the state in total deer kills almost every year. Today there are fewer deer in the county and hunters do not flock here as in the past.

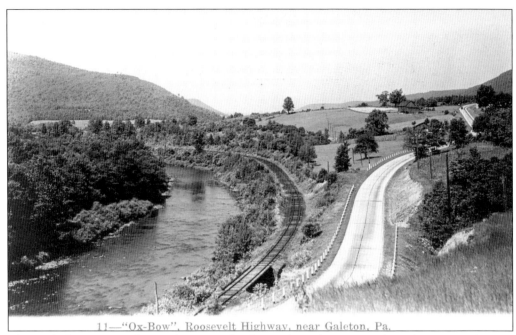

11—"Ox-Bow", Roosevelt Highway, near Galeton, Pa.

This real-photo postcard was taken east of Galeton along the Roosevelt Highway, now known as Route 6, which goes entirely across Potter County and the United States. This unique picture shows three different methods of transportation, including water, railroad, and highway. The term "ox-bow" came from the shape of the road as it proceeds westward in this picture.

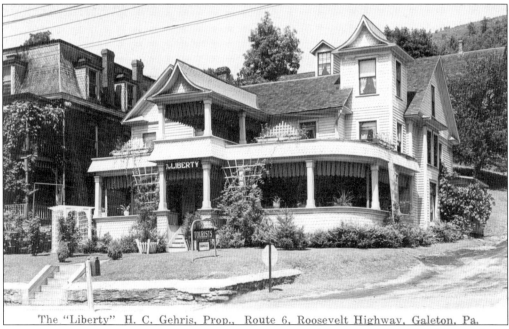

The "Liberty" H. C. Gehris, Prop., Route 6, Roosevelt Highway, Galeton, Pa.

The Liberty was a premier tourist home in Galeton during the 1930s. Take note of the roof style and the immaculately kept grounds around the home. This location is now the parking lot for the Brick House Deli and Restaurant along Main Street in Galeton.

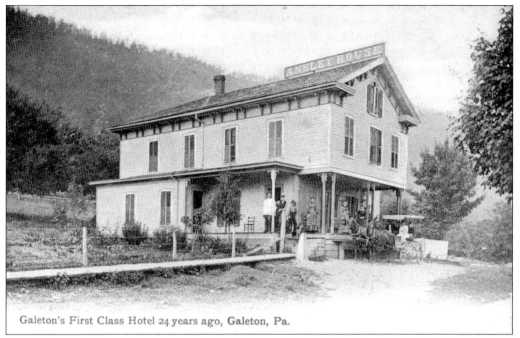

Galeton's First Class Hotel 24 years ago, Galeton, Pa.

The photograph for this postcard was probably taken before 1900, as William Ansley built the hotel in 1874. The Edgecomb Hotel followed this building on the same site. Presently the Galeton Moose lodge is at this location.

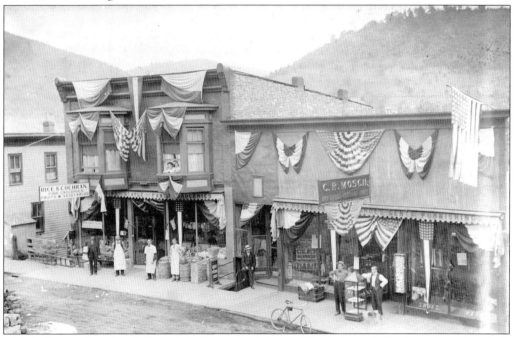

This is the south side of West Main Street in Galeton. The Rice and Cochran Store is at left. It marketed groceries, fruits, and vegetables. The other store is the C. P. Mosch dry goods, clothing, and shoe store. The 48-star flag indicates this photograph was taken sometime after 1911 or 1912. Take notice of the bay windows in the Rice and Cochran Store.

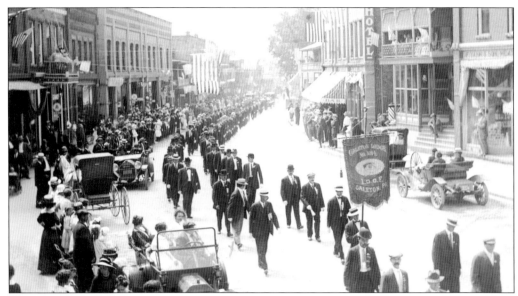

A 1914 street parade in Galeton, led by the Galeton IOOF (Independent Order of Odd Fellows) lodge is seen in this George Clark real-photo postcard. Most of the shown buildings are now gone due to fires and contractors. Both small cars appear to be Ford Model Ts. The view looks from east to west on Main Street.

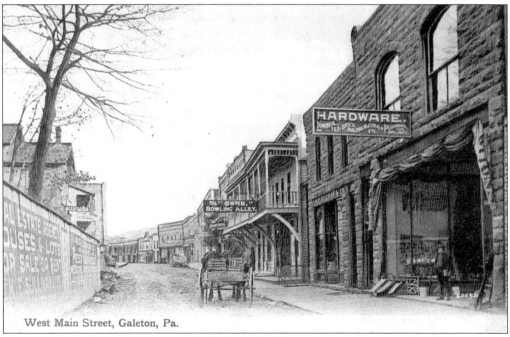

This is a view of West Main Street in Galeton looking east when it was still a dirt road. The picture was probably taken when Galeton was at its peak in population. It was the only town in Potter County to reach over 4,000 people in any census. Note the retaining wall is used for advertising.

Two
GALETON'S RAILROADS

In the early part of the 20th century, Galeton was the railroad hub of Potter County. The Buffalo and Susquehanna Railroad, built and owned by the Goodyear brothers, was expanding out of the woods and into other towns and cities in the east where they had additional business interests.

William Gale and his son Loring Robinson Gale, who had a tanning mill in the Honesdale area of Pennsylvania, thought that Pike Center was an ideal location for another mill because of the vast forests of hemlock surrounding the town. In 1880, after buying land west of town, they finally decided to locate their mill directly in Pike Center. It was located east of the present-day West Street and the bark supply was piled to the west of the mill in the area of today's shopping center. There were three stacks of bark all about a mile long. Rail sidings between the rows allowed for the bark to be delivered by train. In 1881, the first hides were shipped to Wellsboro by wagon. After the railroad came to town, delivering finished hides and receiving raw ones became easier.

The Gales built their homes along West Street. They also built about 30 homes for tannery workers. As the Gales were very generous people, they also purchased the land for the West Hill Cemetery. Tannery workers could use the cemetery free of charge if needed. In 1885, Pike Center was renamed Galeton in honor of William. Galeton was incorporated in 1896.

Today Galeton and the surrounding mountains and small villages are a beautiful destination point for visiting or living a slower pace of life away from fast-paced big cities. Many people have built homes and vacation cottages in the area, sometimes riding snowmobiles and all-terrain vehicles, or hiking on trails that once had steam engines and railroad cars filled with logs screaming their way to the mills.

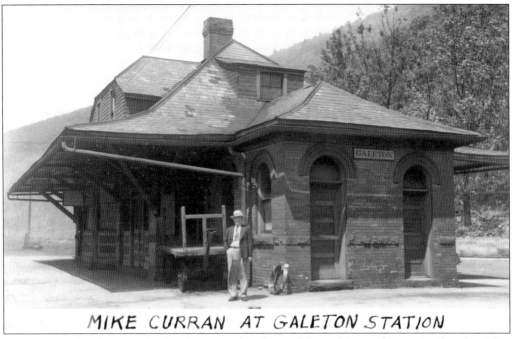

MIKE CURRAN AT GALETON STATION

In 1893, Galeton became the headquarters for the Buffalo and Susquehanna Railroad, with a roundhouse and shops on the West Branch. This is an F. A. Bonke real-photo postcard of Mike Curran, assistant trainmaster for the Buffalo and Susquehanna Railroad station at Galeton. The photograph was taken on June 20, 1947.

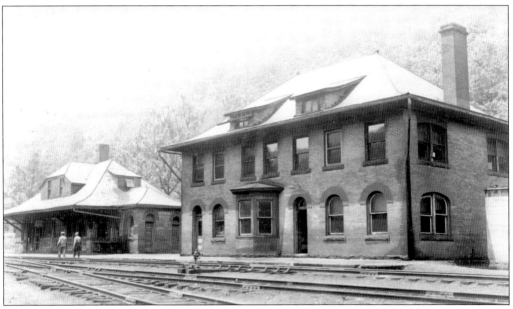

This is a Bonke real-photo postcard of the Baltimore and Ohio Railroad station and office building at Galeton on June 26, 1948. These buildings served the Baltimore and Ohio Railroad, the Buffalo and Susquehanna Railroad, and later the Wellsville, Addison and Galeton Railroad. The buildings are still standing today but not in use.

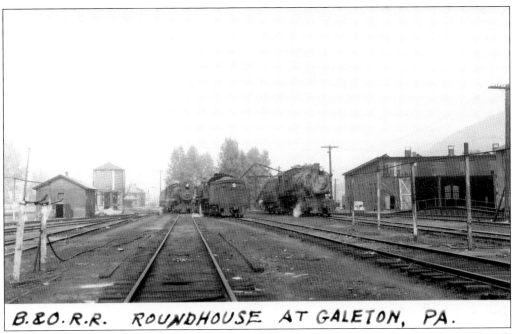

Bonke took the picture for this real-photo postcard view of the Baltimore and Ohio Railroad yard, roundhouse, and turntable at Galeton. The photograph was taken from the machine shop door on June 24, 1948. Galeton was a very busy railroad hub in the early part of the 20th century.

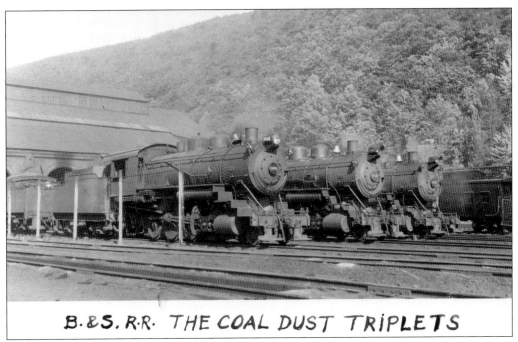

Here is a real-photo postcard of the so-called "Coal Dust triplets," parked at the Galeton Shops. Engine Nos. 3128, 3134, and 3135 are ready for the road. Galeton was the hub of the railroad industry in Potter County during the railroad era. Bonke, who was from New Jersey, took this photograph on June 18, 1947.

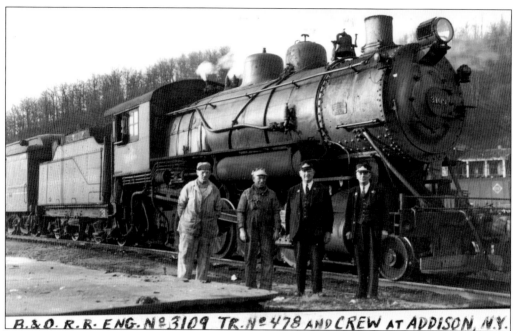

Another F. A. Bonke real-photo postcard shows the Baltimore and Ohio Railroad engine No. 3109 with its crew. The photograph was taken at Addison, New York, during a scheduled run. From left to right are fireman Herman Zeaman, engineer J. J. March, trainman Todd Evans, and conductor Gus Horn. Evans was the grandfather of the author's wife.

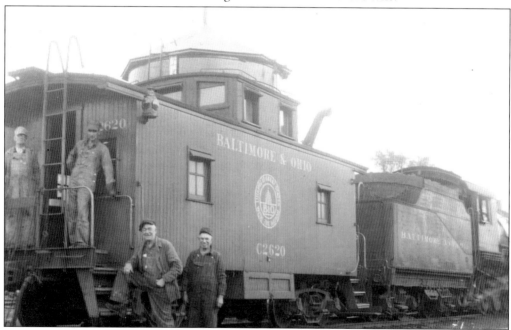

Here is the Baltimore and Ohio Railroad caboose No. C-2620 from Galeton. From left to right are conductor John Long, brakeman Charles Evans, brakeman W. O. Culver, and an unidentified engineer. Bonke took this photograph during a water stop at Wellsville, New York, on June 20, 1947. Charles was the father of the author's wife.

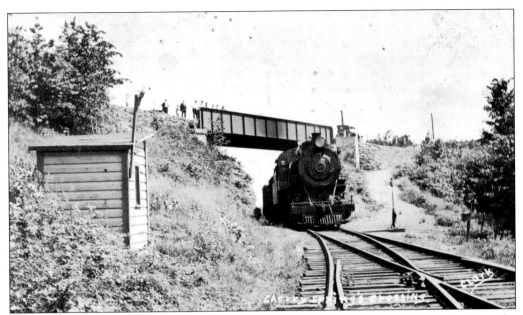

This is a George Clark real-photo postcard of a train arriving at the Cherry Springs station. The overpass carries traffic on Route 44 above the trains. Today this area looks much different, as the train and station are gone and the overpass is filled.

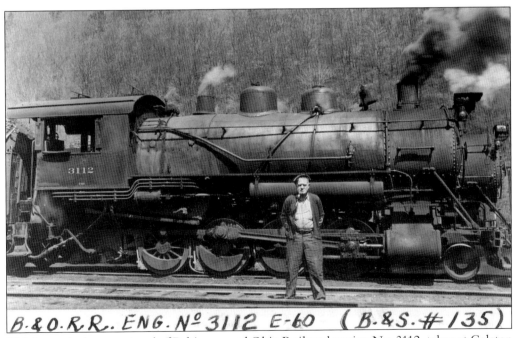

This is a real-photo postcard of Baltimore and Ohio Railroad engine No. 3112, taken at Galeton in May 1950. Standing alongside the engine is engineer Frank Brown. Galeton was the center of the railroad industry in Potter County for many years.

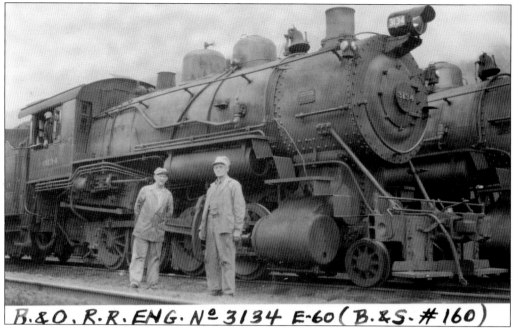

B.&O.R.R. ENG. Nº 3134 E-60 (B.&S. #160)

Steam engines were the king of the railroads before the diesel engine came on the scene. This is a real-photo postcard of Baltimore and Ohio Railroad engine No. 3134, taken at Galeton. Standing alongside the engine is Gus Johnson and Fred Shaar.

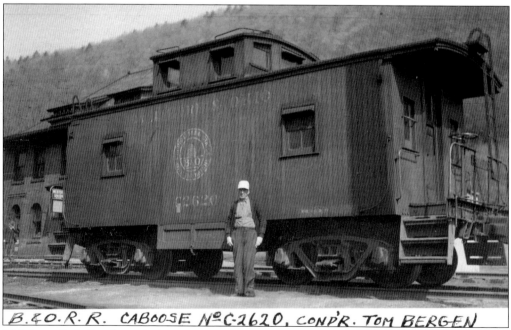

B.&O.R.R. CABOOSE Nº C-2620, COND'R. TOM BERGEN

This is an F. A. Bonke real-photo postcard view of the Baltimore and Ohio Railroad caboose No. C-2620, taken at Galeton on May 16, 1950. Standing alongside is conductor Tom Bergen. Today's trains do not use cabooses. Instead, an end-of-train flashing light is installed on the coupling of the last car.

Three

ORIGINAL COUDERSPORT

The trustees for the Ceres Land Company decided that the Potter County seat of government should be located near the center of the county on the west bank of the Allegany River, where Mill Creek entered the river. The location was sometimes referred to as the forks of the Allegany. At this location, the river changed its course to westward. After flowing through western Potter and McKean Counties, the stream entered New York State, making a bend back southward about where the glacier had blocked a north-flowing river 10,000 years previous.

Even after several families located at Lymansville, no one settled at the future county seat that had been named for John Coudere, a member of an Amsterdam banking firm and an investor in the Ceres Land Company. In 1882, John L. Cartee became the first permanent settler of Coudersport. He purchased the square on which the county jail is now located and constructed Coudersport's first tavern called the Cartee House.

When Potter and McKean Counties were partially organized in 1825, Timothy Ives of Bingham Township was elected county treasurer and soon moved to the seat of government. He built a store on East Street. The third resident was Michael Hinkle, son-in-law of William Ayers. He settled on the courthouse square and operated a blacksmith shop.

The first courthouse-jail was soon too small and a few people wanted a larger, more attractive building. The proposal immediately met with opposition. Many county residents who had experienced difficulty receiving goods or trying to ship their products to the market wanted an outlet to civilization. Most felt that this should be in the form of a plank road to meet the Erie Railroad in the vicinity of Wellsville, New York.

In spite of the opposition, the commissioners voted to build the new building, which was started in 1851 and completed the next year. The building, with some major changes 25 years later and again during the Depression, has served the county for 125 years. So many functions have been added to county government that offices are now located at various borough locations.

For several decades, plans have been discussed to alleviate the overcrowding problem, with no action. Perhaps the near future will see changes.

When the borough was incorporated in 1848, there were about 200 residents. There were already five lawyers in town. Thirty years later, only 677 residents awaited an outlet to trade with outside areas. In 1882, this came in the form of the Coudersport and Port Allegany Railroad, and 20 years later, Coudersport supported over 3,200 people. The population has remained constant, but it has never again surpassed 1,900.

Constructed in 1852, this building replaced the combination courthouse-jail on the same site. It was remodeled during the late 1880s, when the present town and justice statue was added. Although somewhat crowded in its effort to conduct today's business, this building still serves the community.

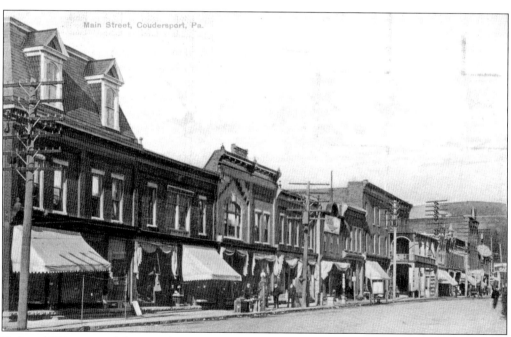

Before 1880, most of the Coudersport storefronts were made of wood in the Greek Revival style built before the Civil War. This picture of Main Street in Coudersport is from First Street looking north. It shows some of the brick construction that followed the fire of 1880.

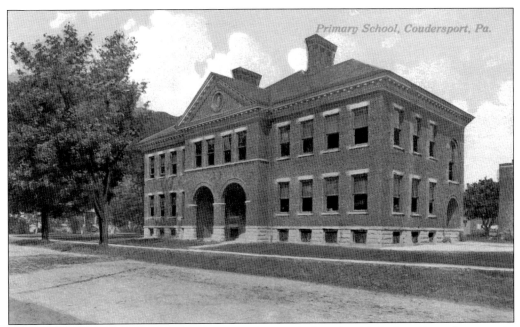

Randall Wilmont built the first building on this site before the Civil War. For a few years in the 1890s, this residence was used as a school, which was inadequate. The first school building was built on this site about 1900. After a few years, it was enlarged to the pictured design and was used until 1912, when it was destroyed by fire.

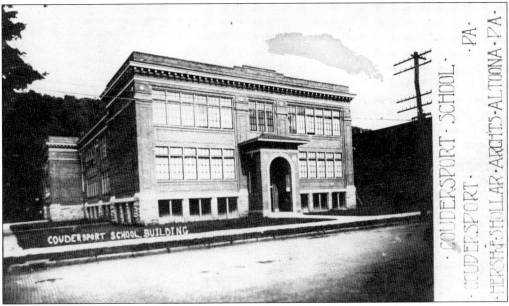

This school was built in 1917 and 1918 as a high school. When the old high school burned, six rooms were added on the First Street school to house the elementary students. The gymnasium was built by the Project Works Administration during the Depression. In 1960, the junior-senior high school was moved to a new location, and this building served as an elementary school. Adelphia last used the building.

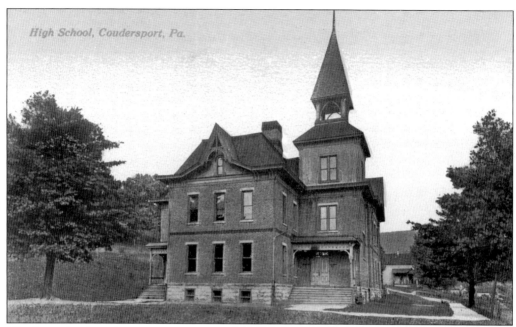

The first school on this site was the academy, built in 1840. It served the residents from a wide area for over 35 years. The academy was replaced with the pictured building in 1878. This school served until 1917 or 1918, when it was destroyed by fire.

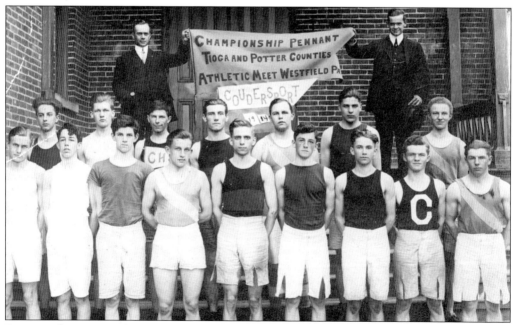

For several years, Coudersport High School fielded championship track teams. This picture was taken in 1914 after the team won the pennant at the Tioga-Potter meet at Westfield. The picture was taken in front of the school on the hill.

The Mann family was a leader in the local Underground Railroad movement and the fight against alcohol. As a memorial, this fountain was erected in front of their home in 1903. It was a three-tiered fountain that served pets, people, and horses. The Mann home was located on the site of the present Coudersport Post Office.

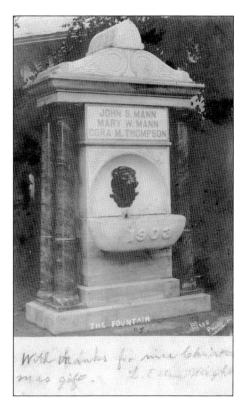

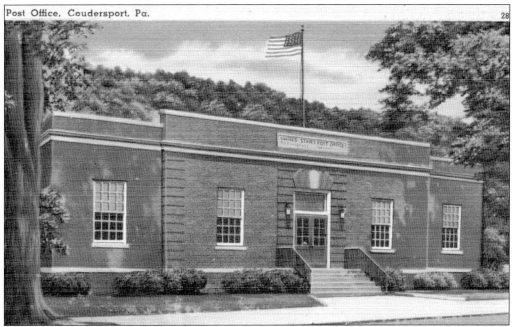

The Coudersport Post Office was constructed in 1936 and 1937 on the site of the former John Mann home, which was the headquarters for the Underground Railroad in Coudersport. This building is still meeting the needs of the residents today.

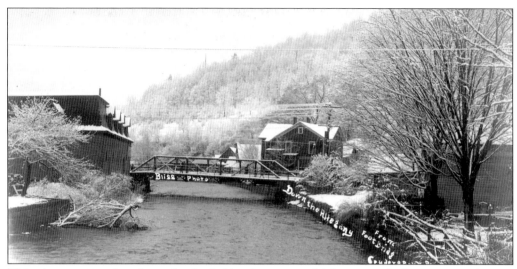

This picture was taken from the footbridge in town, which was washed away several times throughout the years. The picture shows a brick livery stable on the left. The house at the right of the bridge was the location of Austin's Meat Market. (Potter County Historical Society.)

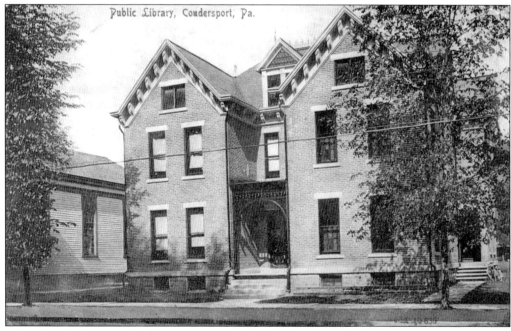

When this building was built in 1892, the south side contained Judge A. G. Olmstead's law office and the Coudersport Public Library. The north side was a residence. After Olmstead's death, all of the south side became a library. In 1954, the historical society purchased the northern half of the structure. Since the library moved to its new quarters across town, the society has occupied the whole building.

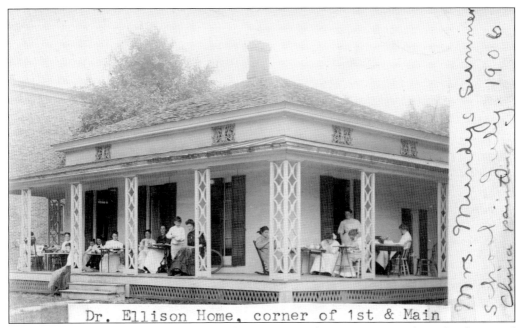

Dr. Obidiant Ellison was one of the first doctors in Coudersport. He was also a developer and businessman in the area. The home was torn down in 1920 and the Main Street Theatre was built on this site, and it still serves the community today. (Potter County Historical Society.)

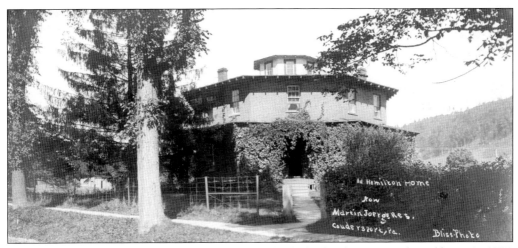

John Hamilton, an agent for a local land company, built this brick octagon-shaped home in 1857. It served as a home until the 1930s, when it was torn down and replaced by a silk mill. (Potter County Historical Society.)

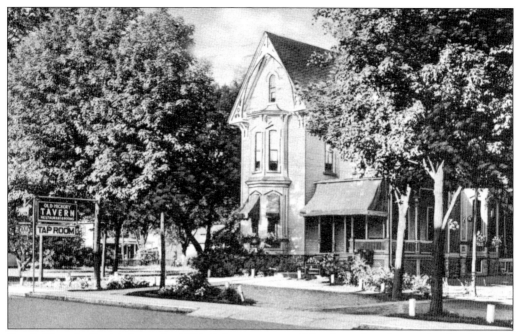

Frank Knox built this home in 1880. It became one of the showplace homes in Coudersport. About 1920, it was turned into a tourist home. After prohibition, a bar was added. It is presently vacant.

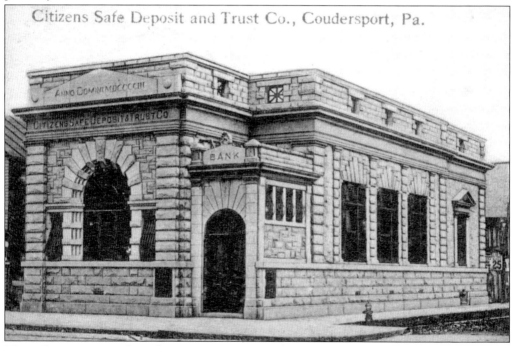

Many pictures were made on this site. In 1886, L. R. Bliss, Coudersport's most active photographer, built a gallery here. Ground was broken on August 9, 1903, for the Citizens Trust Company bank. It moved into its new building on October 12, 1904. The bank moved to new quarters about 1972. Today the building is the office of attorney D. Bruce Cahilly.

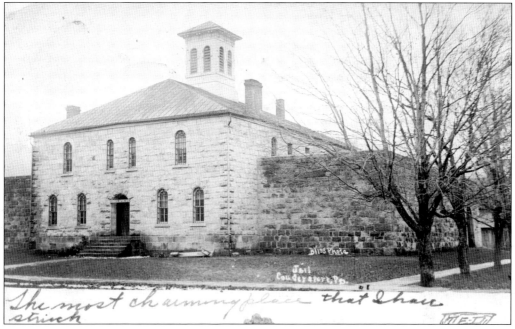

Potter County's first jail was located in the courthouse built in 1835 and remained there until 1869. When the present building was erected, many of the stones were taken from the old courthouse-jail. When it was first built, the downstairs contained dungeons, which later were converted into office space. The building was renovated in 1995.

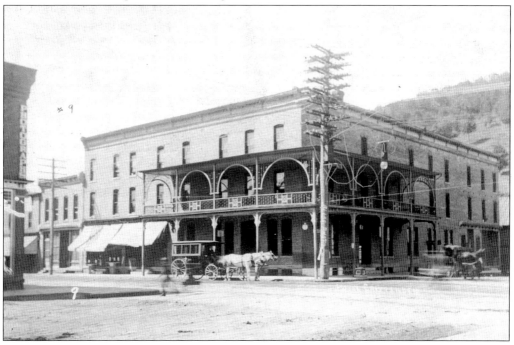

The Crittenden Hotel was built in 1890 after the site sat empty after the fire of 1880, which destroyed the Glassmire House that had occupied the lot for over 30 years. The stage in front may have come from the railroad station or from a nearby village.

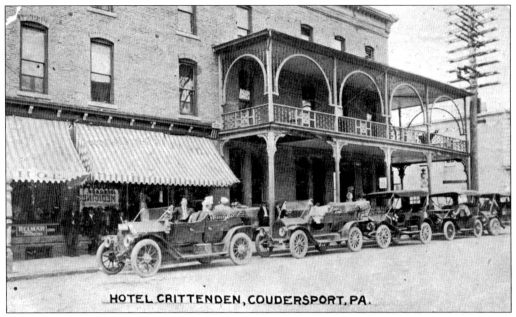

This picture of the Hotel Crittenden in Coudersport was probably taken about 1913 with the vintage cars from 1910 to 1912 parked in front of the building. Also shown are the porches extending around the first and second floors of the east and north sides of the building. All of these have since been removed. The hotel is now one of Coudersport's premier restaurants.

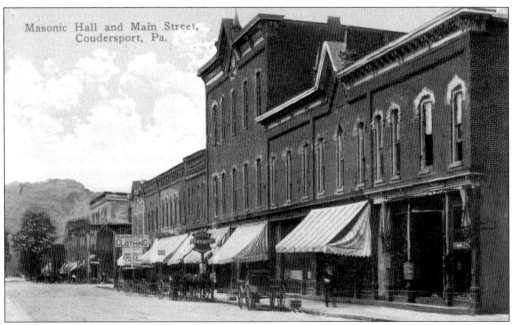

This is Main Street looking from north to south. In 1880, this section of Coudersport burned. All of the buildings shown were rebuilt in 1880 and 1881. The Masonic building is the three-story building and was built on the original Masonic building site. This building is also where the Coudersport Consistory met when it was first formed. The picture was probably taken about 1900.

Four

EULALIA VILLAGE AND ADDITIONS

The railroads made such significant changes that even the lumbermen began to depend on them. By the beginning of the 20th century, business was booming, the forests were used up, and loggers moved south and west to new uncut areas. Other industries emerged, and mills and small factories came and went. A tannery built in 1878 supported a large part of the population for a century. It closed in 1978. The most recent stable industry, the Pure Carbon Company, began here in 1959 and has expanded several times. At times, it has employed over 300 workers.

In 1895, the borough lines were extended to include what was Eulalia Village, south of the river, and the tannery to the west. The eastern line was moved to include Ladona, formerly Lymansville. Other adjustments were made over time.

The period from about 1890 to 1915 was the time of greatest home building within the borough. The change brought by the entrance of the railroad caused enough prosperity to create a rather stable borough.

The motor car, which has dominated everyday life for the last century, first appeared in town in 1903. It competed with the railroads until the 1970s, when the tracks were taken up. The iron horse disappeared from the county except for a few miles at Keating Summit.

The automobile took a few years to be accepted, and the streets were paved with brick. The commonwealth took the farmer out of the mud, making travel into town a pleasant trip. Also Henry Ford and his Model T made it economically possible for the farmer and the working man to afford a car, changing Saturday night from only a bath time to a time to get out and shop and see the sights.

For the last 50 years, the area has been in a constant search for the magical answer to its economic ills. Adelphia was the great savior for over 30 years. Now the search has begun again.

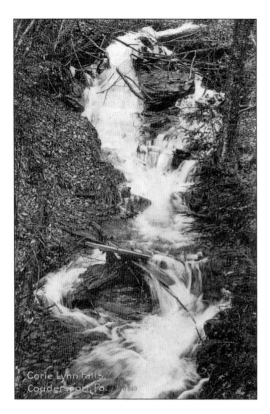

Cora Lynn Falls rises from several springs located on the east side of Ross Glen. In the springtime when the water flow is heavier, it is a beautiful sight. The first road southward over Dutch Hill left Coudersport by way of the hollow formed by this and other small streams.

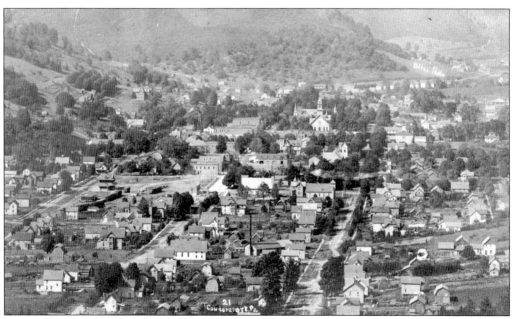

This is a bird's-eye view of Coudersport, looking north. Coudersport was surveyed and laid out in 1807, before there were any people living in the entire county. The streets were laid out in squares, running north to south and east to west.

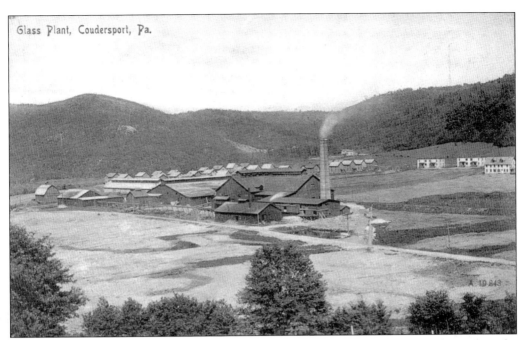

This is the Bradford Window Glass Plant at North Coudersport. The plant was located on the site of the present Alliance Church. It built 37 homes for employees at the same time that it built the plant. The plant was built in 1899, and after only a few years of operation, it closed, later to become the American Silver Truss Corporation.

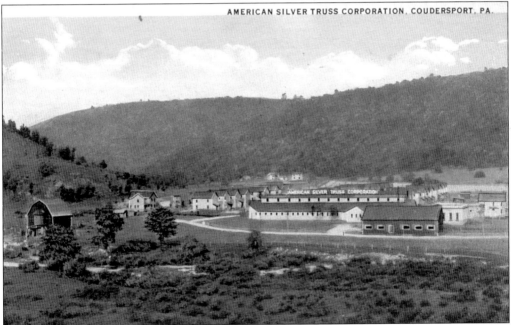

In June 1911 the American Silver Truss Corporation purchased the vacant glass plant. It hired both men and women and for almost 40 years, made trusses and other rubber products for the national market. During its years of operation, North Coudersport was often referred to as "Rubber Town."

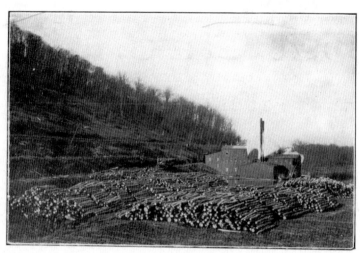

Dodge Clothespin Plant,

Coudersport, Penn'a.

Manufacturers of THREE SIZES of CLOTHESPINS

BOSS, DAISY and WESTERN, in Bulk and Cartons. There are no better made. Count and Quality correct. Write for prices. Dodge Clothespin Co., Coudersport, Pa.

This is the Dodge Clothespin Plant at Coudersport. It manufactured three sizes of clothespins, the Boss, the Daisy, and the Western, in bulk or cartons. The plant operated from 1890 to 1911, closing due to the lack of beech timber for their product. When leaving the Coudersport area, the plant moved to West Virginia.

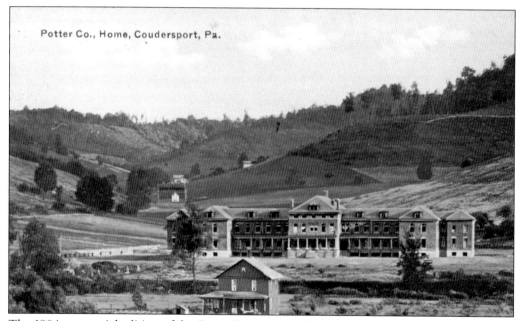

Potter Co., Home, Coudersport, Pa.

The 1904 centennial edition of the *Potter County Journal* lists the county home as a place where the indigent and mildly insane receive humane treatment under a rational system. The home and 400-acre farm was located at East Coudersport. The farm was used to help feed the residents of the home.

The house part of the Coudersport Consistory was built by Isaac Benson in 1887 as a residence. In 1913, the Coudersport Scottish Rite Bodies purchased Benson's former residence for its future home. That same year, the first addition was added to the building. The cornerstone for the present auditorium was laid on October 27, 1928, and dedicated in 1929.

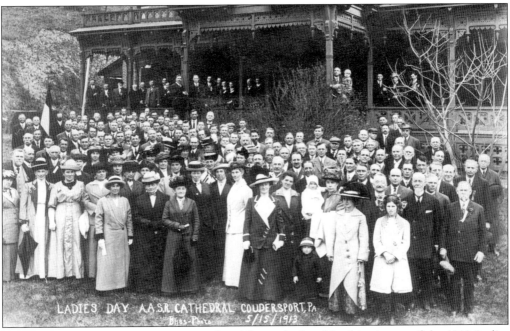

Membership in the consistory increased rapidly, as depicted in this picture of the 1913 Ladies Day. Coudersport was the smallest town in the United States to have a consistory that offers the 32 degrees in Freemasonry.

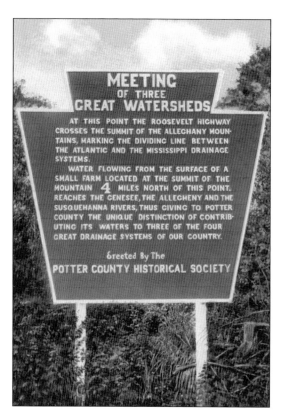

The sign shown here was located near the top of Denton Hill years ago. It was titled the "Meeting of the Three Great Watersheds." The sign says it all. It was very unique.

This is Worthington's Tourist Camp, located near the top of Denton Hill. It possibly opened in 1926 when the new road from Sweden Valley to Walton was completed. This business was located at one of the highest points on Route 6 in Pennsylvania. It is 2,425 feet above sea level.

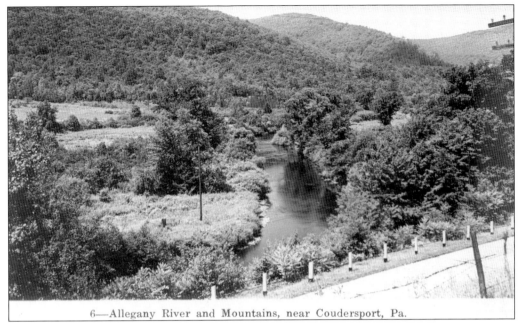

6—Allegany River and Mountains, near Coudersport, Pa.

This picturesque view of the Allegany River and mountains was taken just west of Coudersport. Although the card is not marked, the picture was probably taken in the 1930s. There are many views like this throughout Potter County and may be one of the reasons for the phrase, "God's Country."

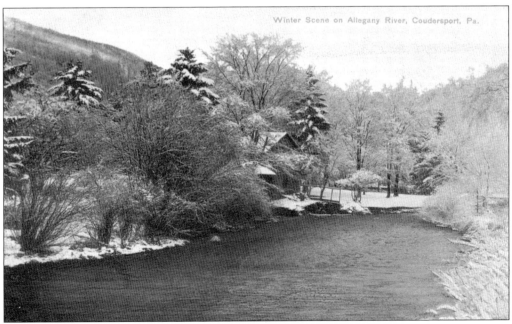

A typical winter scene on the Allegany River near Coudersport is pictured in this photograph from the very early 1900s. Winter is a very pleasant time of the year for many residents of the county.

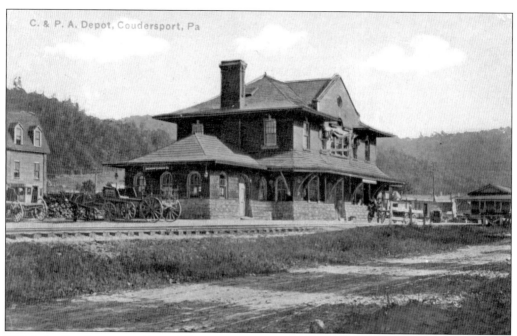

This is the Coudersport and Port Allegany Railroad depot in Coudersport. The first railroad came to town in 1882 and ran from Coudersport to Port Allegany 17 miles to the west. The first station was located next to Main Street. The pictured station was built in 1890. The building seen to the left is the Eulalia Milling Company. The small building on the right is the freight station.

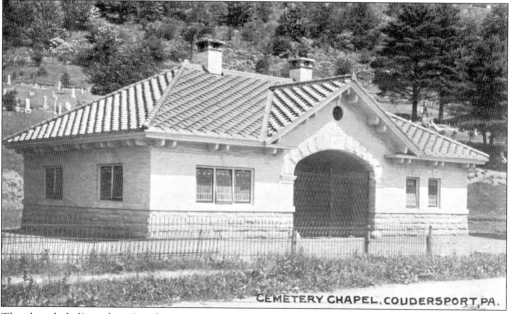

The chapel, dedicated on October 15, 1911, was a gift of Mrs. John Archibald, a former Coudersport girl who married a Standard Oil executive. For almost 100 years, the building, dedicated to her parents, Samuel and Lavinia Mills, has been the center of many burials.

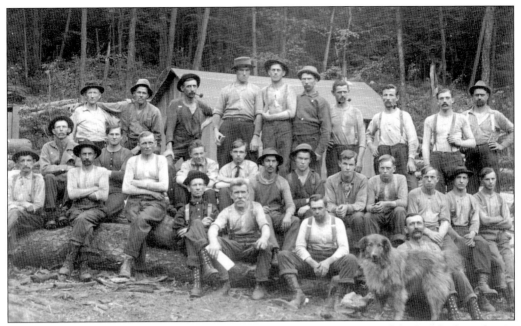

Jobbers who established camps to house the workers cut the majority of the hemlock timber in the county. This is a picture of a medium-size logging camp crew in the mountains of Potter County. (Potter County Historical Society.)

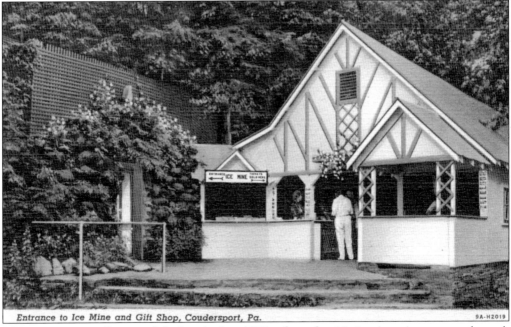

The ice mine was discovered during the late 1800s after a few Native Americans came through the area with silver ore they claimed was found to the south of Sweden Valley. When local residents dug a hole in the ground, it filled with ice. This was turned into a tourist attraction around 1900.

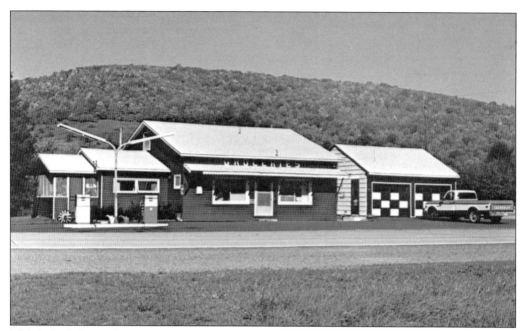

This is Ruby's Rock Run Trading Post, located in Ulysses Township along Route 6 between Galeton and Coudersport. It was nestled at the foot of the mountains in the heart of Potter County, or "God's Country." The business was a favorite spot where hunters, fishermen, and tourists alike got acquainted over a cup of coffee in the 1950s.

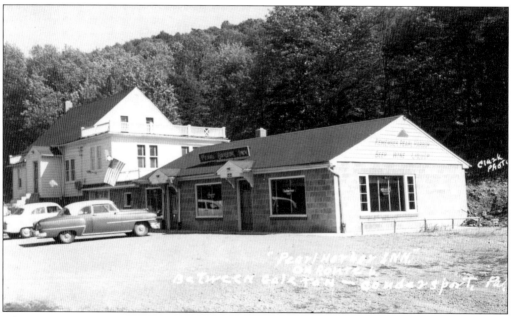

This is a George Clark postcard of the Pearl Harbor Inn, located along Route 6 between Galeton and Coudersport. It was in operation during the 1950s as a barroom. Is that a 1949 Pontiac parked in front of the building? It was also home to a ceramic business in later years and is now a private residence.

Five

AUSTIN

Austin, first called Freeman Run, was founded in 1856 when E. O. Austin purchased a farm on the site. The name was changed in 1888 after the town grew up around the Goodyear Hemlock Mill.

Austin grew from a few early farms into a boomtown lumber center with 1,670 residents in a little over two years. In 1883, Frank Goodyear purchased a vast track of the virgin forests in southern Potter County and his logging empire began to grow.

It was also in this same year that he worked with the Marion Steam Shovel Company to build a log loader for use in the woods. This proved very successful and was the first labor-saving piece of machinery to be used in the mountains of Potter County. It now required only three men to load the log cars for transportation to the mill. Previously it required a large crew to roll them onto the train cars.

In 1897, the Goodyears bought a second mill in Austin that was located east of the big mill. After putting band saws in the two mills, they had a possible annual capacity of 120 million board feet if both mills ran double shifts.

After 1901, the Emporium Lumber Company cut all the hardwood off of the Goodyear lands. About this time, George C. Bayless built a paper mill in Austin to make use of the softwood trees and tops too small for lumber.

By 1911, the Goodyear mill was only being used part-time to saw some miscellaneous tracts being cleaned up in the area. However, the paper mill continued to operate and provide local employment. On September 30, 1911, in about 15 minutes, a torrent of water from the paper company's dam swept away hundreds of homes, wiped out most of the business district of town, and drowned about 75 people on its way down the valley. The paper mill did resume operations and ran until it was flooded again in 1942, when it was destroyed.

Today there is no significant industry in this area. Most of the land that was owned by the Goodyears is now owned by the State of Pennsylvania. Cabins and summer homes outnumber permanent residences, and tourism is an important industry. Many of the old railroad beds are still in use today by cars, all-terrain vehicles, and hikers.

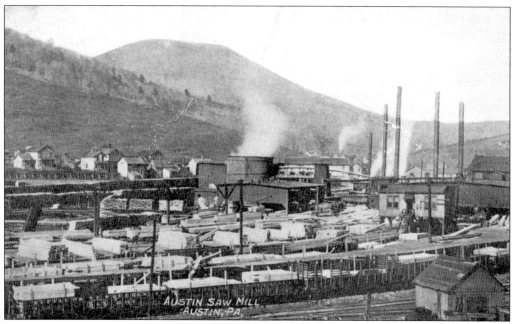

This is a view of the Goodyear Hemlock Mill at Austin with its large lumberyard. A number of Buffalo and Susquehanna Railroad cars are being loaded with sawed lumber at the bottom of the picture. The card was mailed in July 1911, just two months before the big flood.

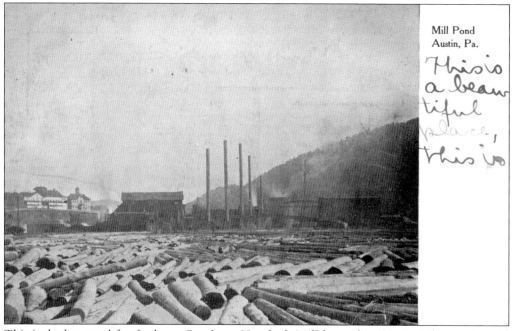

This is the log pond for the large Goodyear Hemlock Mill located in Austin. The pond could only hold enough logs to supply the mill for one day. The Hemlock Mill employed about 175 men with a monthly payroll of around $8,000. It was equipped with electricity and usually ran 22 hours a day.

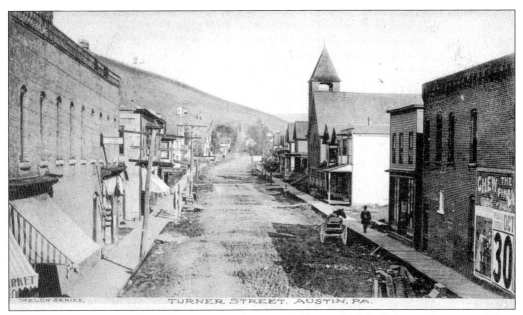

Turner Street ran parallel to the mountains between Elliot and Main Streets. Many people lost their lives while trying to go up the mountain when they encountered high fences that bordered the lots in back of the houses on the west side of the street. This view of Turner Street was probably taken around 1906.

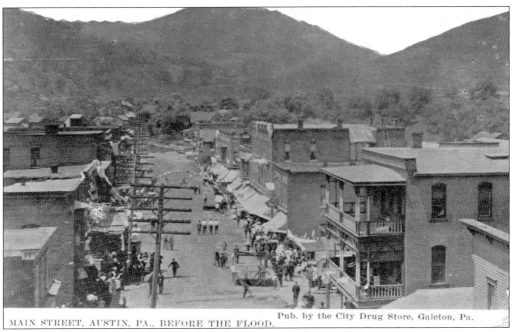

Main Street in Austin is shown here on a very busy day before the September 30, 1911, devastating flood. This photograph was probably taken around 1906 when Austin was a booming town. The 1910 census listed 2,941 residents, and there was undoubtedly more than 3,000 when the dam broke.

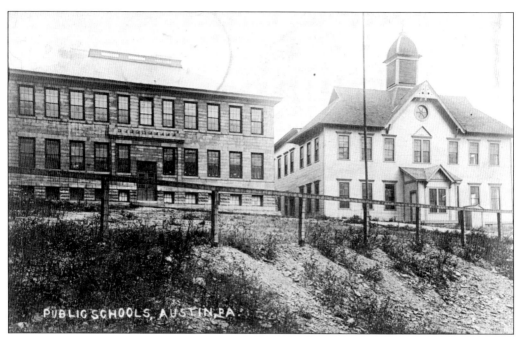

For over 40 years, a one-room school served Austin, but the rapid increase in population put a burden on the existing facility. The town fathers constructed a new school by August 1888 that, with a few additions, served the town for almost 70 years until the present school, which contains all grades, was completed.

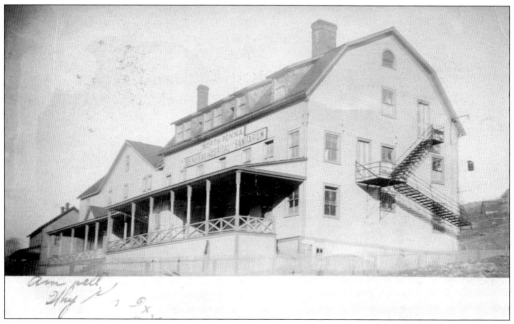

A private hospital was operating on Railroad Street around 1896. In a short time, the need arose for a larger facility. The North Pennsylvania General Hospital was incorporated on September 18, 1899. The opening was cause for a three-day celebration with the Susquehanna Valley Railroad running excursion trains into the town.

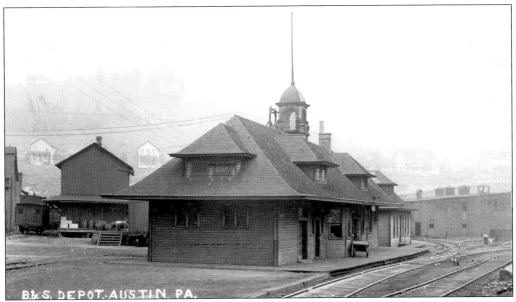

This is a real-photo postcard of the Buffalo and Susquehanna Railroad depot at Austin. It looks like this picture may have been taken shortly after the station was built. Austin was the headquarters of the Buffalo and Susquehanna Railroad until 1893, at which time they moved their management and offices to Galeton.

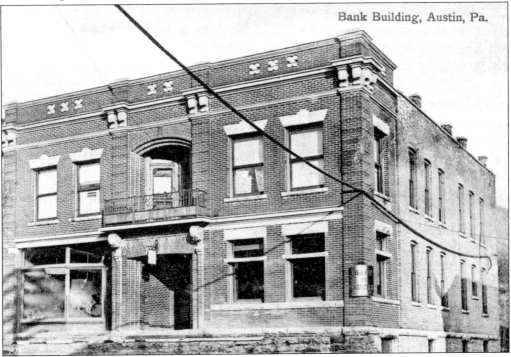

The post office and a bank were housed on the first floor of this impressive brick building in Austin. It was located near the center of town in the path of the flood waters carrying logs and demolished buildings down the valley on September 30, 1911. Although the building received considerable damage, it was repaired and served Austin residents for many more years.

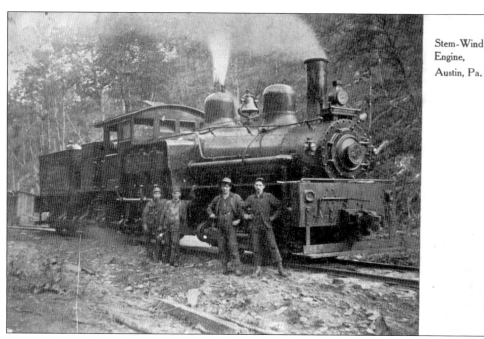

The shay engines used in the woods of Potter County were built in Ohio and worked well pulling the heavy loads of logs over the uneven terrain because all wheels were powered. The Goodyears probably operated this shay in the Austin area to supply logs to their mills.

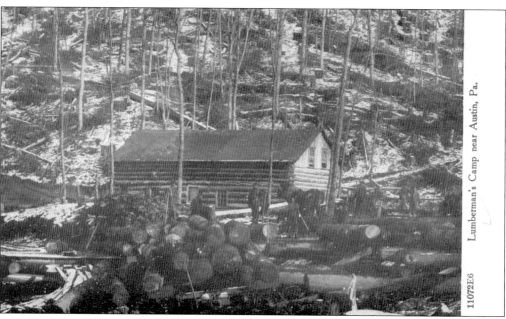

This is a postcard showing a lumberman's camp near Austin. Its construction style was a little unusual, being built of logs. Most lumber camps during the logging era were constructed of sawed lumber, making it easier to take apart for relocating to another area if necessary.

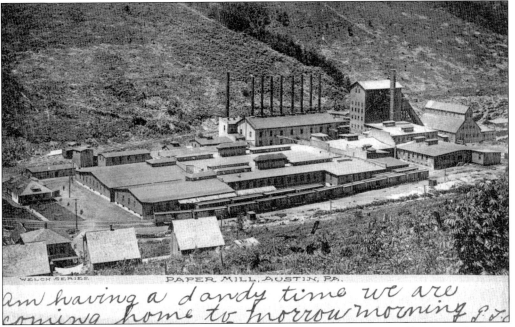

In 1900, George C. Bayless of Binghamton, New York, had become attracted by the timberlands of southern Potter County and began to construct a large pulp and paper mill in the north end of town. Continuous water shortages made it necessary for the Bayless Mill to build a concrete dam above town in 1909.

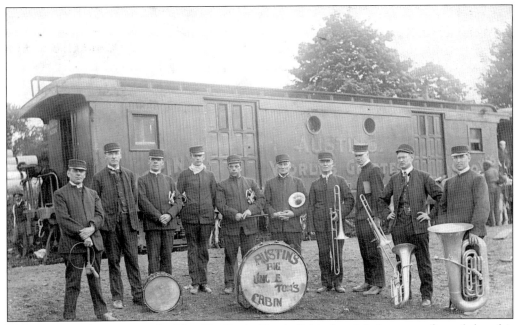

This is a real-photo postcard of the Big Uncle Tom's Cabin band. It is not confirmed that this band was from the Austin area, but the picture is included here because it is so unique. The railroad car appears to have been a combination mail and passenger car. Can anyone verify the location of this band?

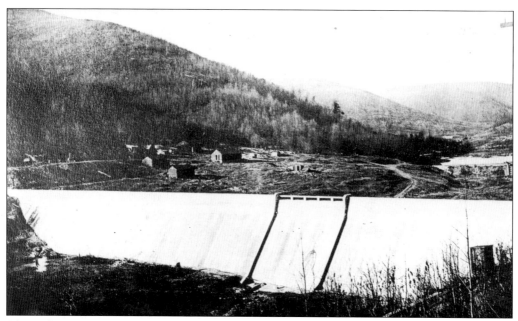

This is the Bayless dam shortly after completion and before it was filled with water. The concrete dam stretched 534 feet across the valley and about 43 feet high and was built at a cost of around $100,000. Most people thought it would stand there forever.

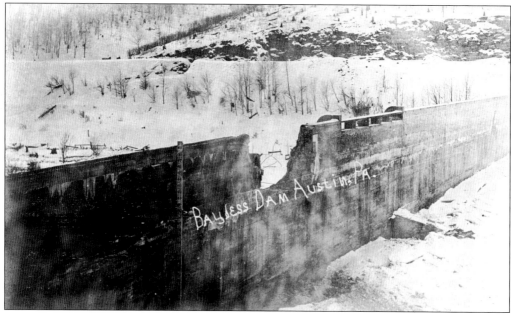

This real-photo postcard shows the Bayless dam at Austin after a section was blasted out to lower the water level by about three feet, relieve the pressure, and stop the concrete from springing any farther. This arrested the movement of the concrete in the dam visible at the top and the people of the town were lulled into a false sense of security.

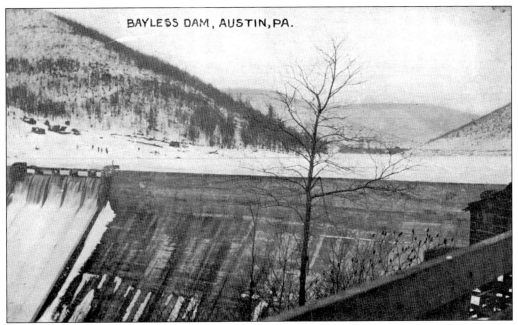

The Bayless dam is shown filled with water. The water coming over the spillway convinced most of the town's population to think the dam was operating as planned. It was now thought the pulp and paper mill would never again run out of water for the production of their products. Note the leaks in the seams at the right of the spillway.

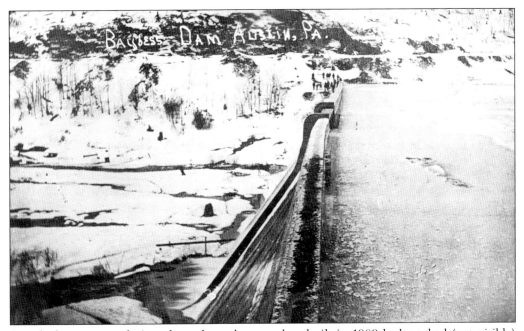

A real-photo postcard view shows how the new dam built in 1909 had cracked (not visible) and sprung about four feet from the pressure of the water behind the dam. In January 1910, a hole was blasted in the top of the dam near one side, releasing about three feet of water to help relieve some of the pressure.

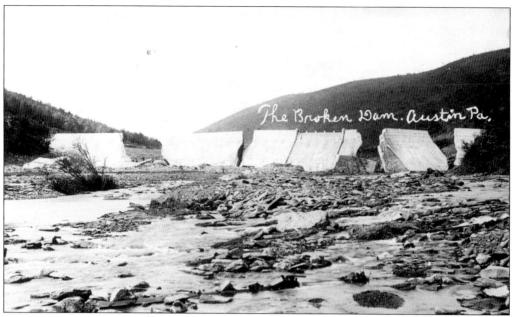

On September 30, 1911, the Bayless Pulp and Paper Company Dam broke, causing the largest catastrophe that ever hit Potter County. The paper mill whistle blew about two in the afternoon after receiving a telephone call from the Cora Brooks boarding home near the dam. In a little over 15 minutes, 75 to 80 people had lost their lives and the town was devastated to the amount of $5 million.

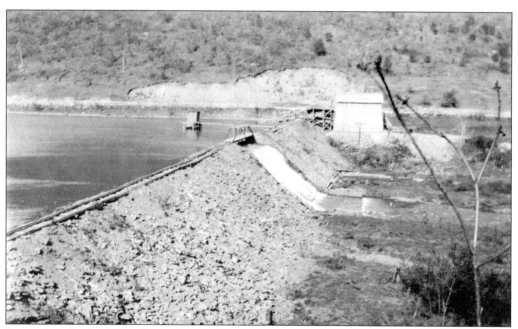

It was first doubted that the Bayless Pulp and Paper Company could continue after the flood disaster, but the company had the plant repaired and rebuilt and ready to put back into operation by December. An auxiliary dam that was built farther upstream in November 1910 was to be used as the main water supply. By this means, the plant started again a few months later.

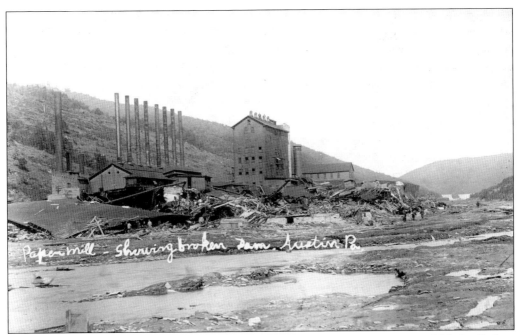

The damage to the Bayless Pulp and Paper Company Mill and the mountain of debris piled up against the buildings are visible here. The plant was repaired, debris cleared away, and the plant was ready for production again by December. Water was supplied to the plant from an older earthen dam above the broken concrete dam on Freeman Run.

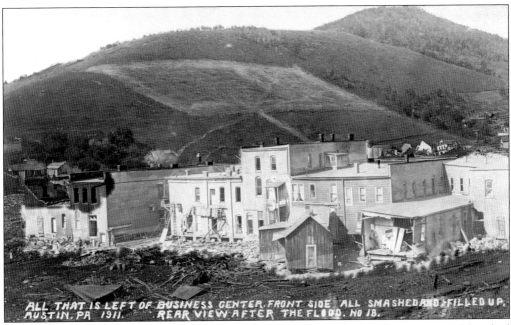

This is what was left of the business district in the center of town after the water and debris had receded. Even though the buildings are still partially intact and standing, they received various amounts of damage that required major repairs. Many tons of debris had to be cleared from around the buildings before reconstruction could begin.

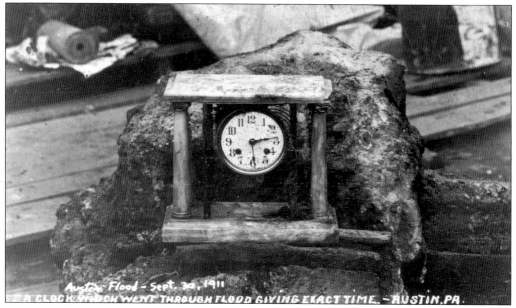

The Lafe Starkweather clock was found under tons of debris on Main Street after the flood had passed. If the time on the clock is correct, it took about 30 minutes for the water to come down Main Street, two miles from the dam. Many people believed it only took half that amount of time.

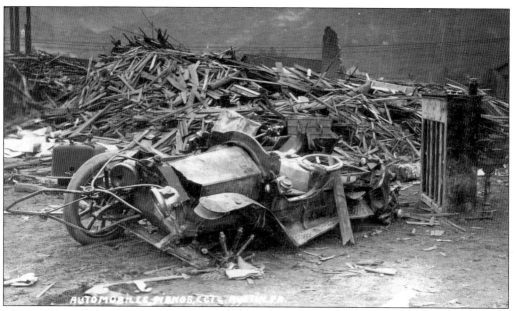

This is a real-photo postcard depicting an old automobile, pianos, a large amount of lumber, and destroyed buildings after the flood had passed through town. Scenes like this were still a common site in some areas of town many months after the floodwaters had passed.

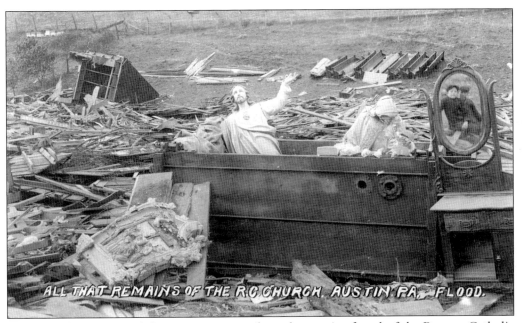

This real-photo postcard shows two statues, the only remains found of the Roman Catholic Church of Austin after the flood. The force of the rushing water and debris turned large buildings into tangled messes of broken lumber in minutes along with great loss of life.

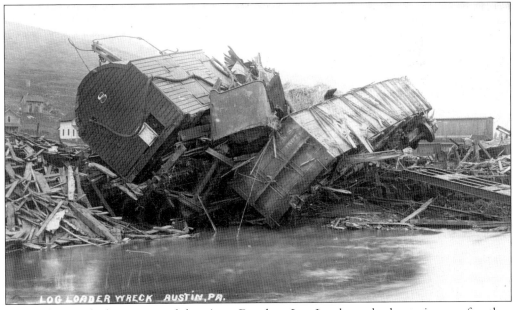

Pictured is a real-photo postcard showing a Barnhart Log Loader and other train cars after they were pushed every which way by the flood waters carrying along the pulpwood and sawed lumber stored at the sawmill and paper mill.

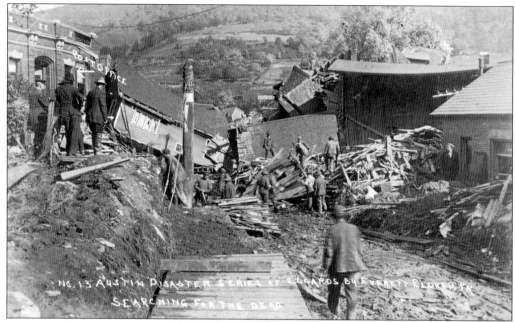

A group of men digging through the huge piles of wreckage looking for bodies of family and friends after the flood is pictured in this real-photo postcard. The post office is identified in the upper left of the picture. It was never known exactly how many people perished in this disaster, as no one person or organization made a complete listing of those found or missing.

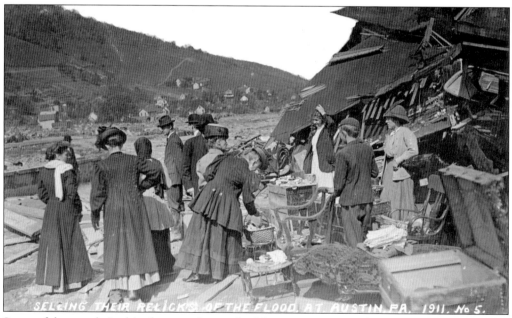

Some of the people in this photograph were looking over souvenirs from the ruins of the Louis Nuschke store after the flood. The four women in the foreground are Mrs. Thomas Buckley, Theresa Dittenhoffer, Mary Van Volkinberg, and Mrs. Jake Faus, all women who had lost their homes.

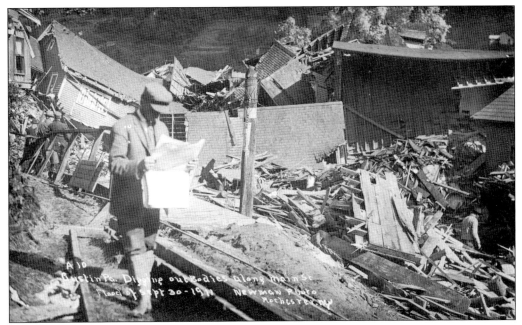

This real-photo postcard shows some workers digging through the huge piles of debris looking for bodies. In the foreground, a man can be seen reading a newspaper, most probably a story about the great disaster in Austin.

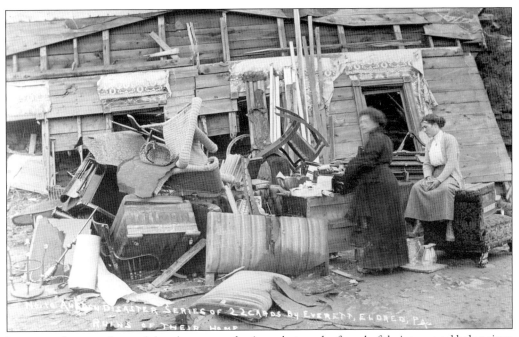

It appears that a mother and daughter are gathering what can be found of their personal belongings and household furnishings. They are being assembled in front of what remains of their nearly demolished home. One can only imagine the thoughts that went through the people's minds on this day.

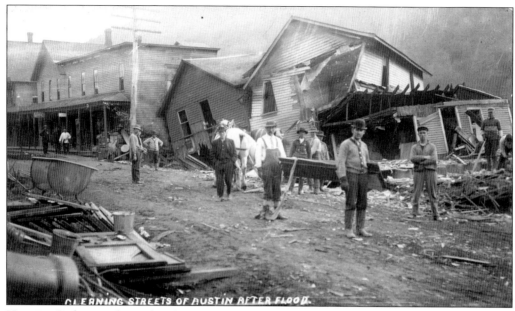

Herman Grabe was the undertaker who, with stretcher and assistants, was searching for bodies. Henry Libbey's house on Costello Avenue can be seen at the right of the picture. Libbey's wife was rescued from the open upstairs room when the house came to a stop.

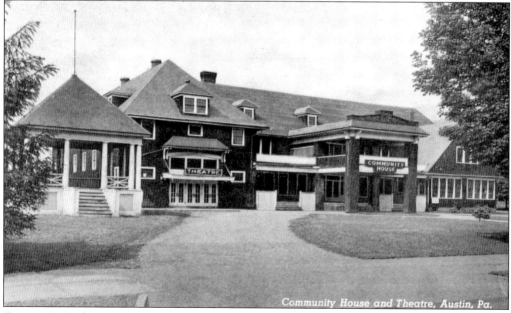

George C. Bayless erected this huge community building on Main Street after the dam broke. It contained a theater, a bowling alley, and a large ballroom on the second floor. The residents of Austin used it until it was condemned in 1972 because of its wooden construction. Austin's new firehouse was built on this site after the community house was dismantled.

Six

Cross Fork

In 1893, almost virgin forests still covered the hills and valleys of the Cross Fork area, as only the white pine had been removed in earlier days. There still remained some of the finest hemlock and hardwood timber in the state.

In the fall of 1893, the Lackawanna Lumber Company started constructing a sawmill near the junction of Kettle and Cross Fork Creeks. At the time, there were only a few families living in this area. The next year, they were building stores and hotels in earnest. The sawmill began operation in 1895 and the Buffalo and Susquehanna Railroad built a branch from its main line south to the town. A logging boomtown had sprung up almost overnight.

The town had a company store, five grocery stores, a dry goods store, a millinery, sporting goods stores, and many other businesses. In its peak year of 1910, the population was near 2,500. It was a very modern town with electric lights, a water system, sewers, and telephone service. The support of all this prosperity was the big sawmill of the Lackawanna Lumber Company. The mill built in 1895 burned down in 1897 but was replaced by a larger mill. This mill was also destroyed by fire in 1903 along with over 10 million board feet of lumber stacked in the yards. An even larger mill that could cut 230,000 board feet a day replaced this mill the same year. The annual value of the lumber cut by this latest mill was over $1 million.

In addition to the timber cut at the mills, probably another 20 million board feet were rafted down Kettle Creek and the Susquehanna River to the Williamsport mills.

The town of Cross Fork was flying high and sawing its way to falling hard. The big sawmill closed in the spring of 1909, and the exodus from the town began. After numerous fires, the insurance companies paid all losses. After that, the insurance companies cancelled the remaining policies and refused to write any new ones. Fires stopped almost immediately and forced sales took their place. In the winter of 1912, the stave mill closed. In the fall of 1913, the Baltimore and Susquehanna Railroad discontinued service and tore up its tracks the next spring. In a few years, the population went from over 2,000 down to about 60. There was only one hotel and a few small stores remaining.

Today Cross Fork is a little hamlet in the middle of tree-covered mountains with some of the best trout fishing in the county.

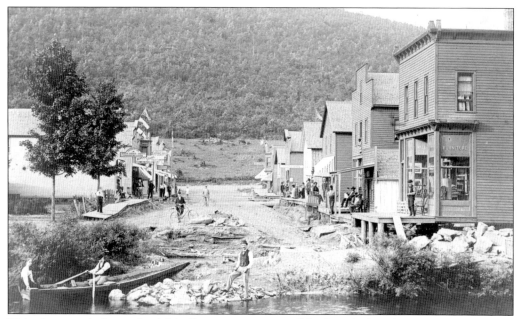

This photograph shows that Main Street was pretty well built up before there was a bridge. The boat was used to accommodate those who wished to cross to the other side. (Potter County Historical Society.)

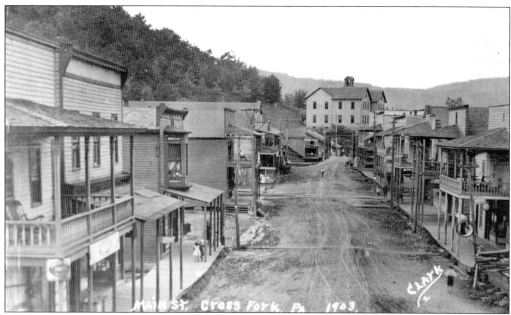

Main Street in Cross Fork is seen in this 1903 view. At this time, it was a thriving community, but as the timber was harvested from the surrounding mountains, the area soon became a ghost town. The town was built at the junction of Cross Fork and Kettle Creeks and its economy relied solely on the continued success of the Lackawanna Lumber Company.

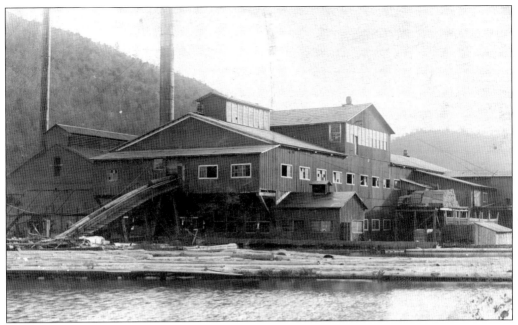

The original mill was destroyed by fire and replaced by a more modern and larger operation in 1897. This new mill was also ravaged by fire and replaced again in 1903. The latest mill had a production capability of about 230,000 board feet per day. A large portion of this lumber was processed at the company's planning and finishing mills. (Potter County Historical Society.)

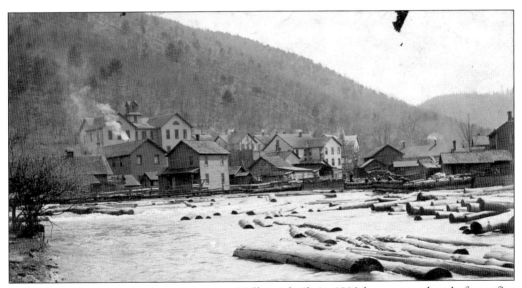

The first Lackawanna Lumber Company Mill was built in 1893 but was replaced after a fire on one New Year's Eve. This picture shows the holding pond where the logs were delivered from the forests. The mill cut mostly hemlock and was one of the largest in the commonwealth, cutting 6,626,170 board feet during 1906. (Potter County Historical Society.)

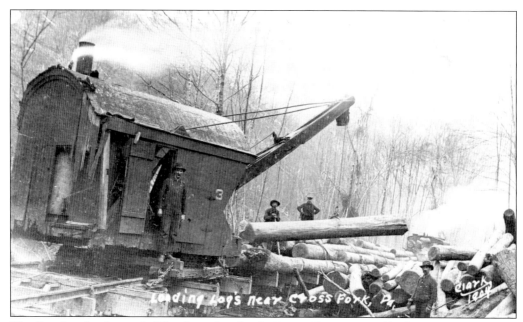

The Barnhart loader made life safer and easier for Potter County wood hicks. Fewer men could load the cars in much less time. The Barnhart ran on rails mounted on top of the log cars and moved under its own steam power. It was common for crews to compete with others in size of loads and time taken to load a complete train of cars. (James A. Marshall collection.)

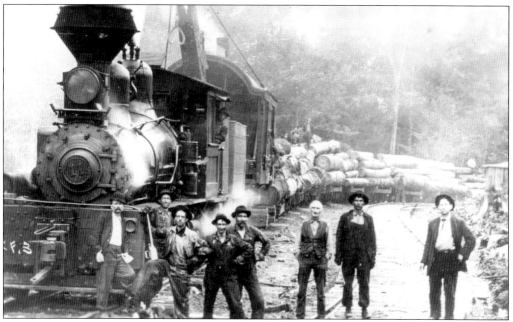

The railroad that served Cross Fork and the Lackawanna Lumber Company was the property of the Goodyear Lumber Company and connected to its main line at Cross Fork Junction about a dozen miles north of town. Lackawanna did own and operate some logging lines. No matter who ran the line, hundreds of log cars unloaded at the mill each day. (Potter County Historical Society.)

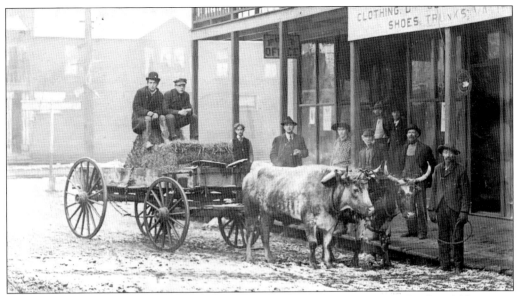

Oxen were slower than horses but more stable, and if one broke a leg, the beef could be eaten. This span belonged to Rube Kelly. The man by the post is Fred Andrews. Note the lack of women in front of the post office and shoe store. The activities of women during the logging era were for the most part centered on home, family, and church.

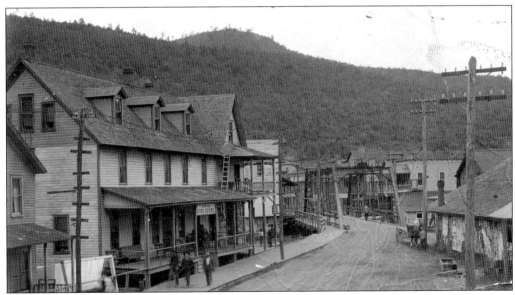

This is Cross Fork in 1907. The Kirk House Hotel can be seen on the left side of the picture. Cross Fork was once one of the best lumber-era boomtowns in the county. It was also at times described as a lusty, brawling town. When the timber supply was exhausted, the industries, the railroad, and the town people soon left.

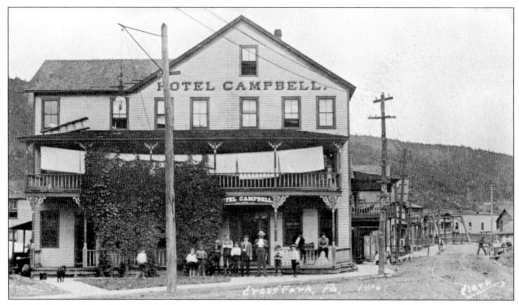

In 1906, the Hotel Campbell was one of seven hotels in town that welcomed any and all travelers coming its way. It served the rough and tough lumber town that boasted a population of 2,500 persons as late as 1910. The village was never organized as a borough, so keeping track of the exact population was difficult.

The Hotel Campbell catered to the many travelers who came by train from the north or by stage from the south. The school on the hill graduated classes until it closed when the population decreased. After less than 15 years, the school that had over 250 pupils needed only one room for the total school population. (James A. Marshall collection.)

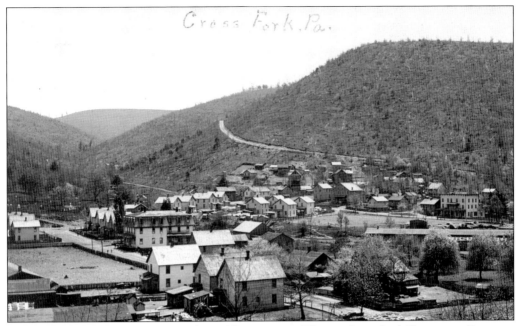

This is a view of South Cross Fork or Clintontown. The road on the hill went to Renovo, located on the Susquehanna River. Sometimes the Cross Fork post office was located in Potter County and at other times it was located in Clinton County.

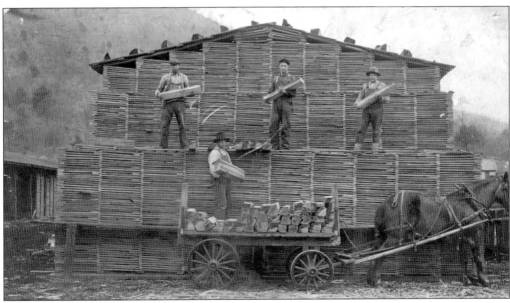

A secondary industry of the lumber mills was the stave factory built by the Pennsylvania Stave Company in 1897. It purchased timber from the Lackawanna Lumber Company but did its own logging. This postcard shows how the sawed staves were transported from the saw and stacked and stored outside until needed in a factory to produce wooden barrels of various sizes.

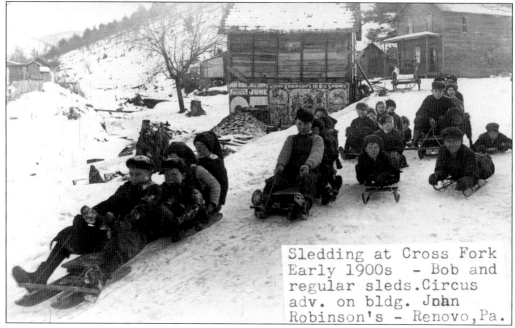

Sledding at Cross Fork Early 1900s - Bob and regular sleds. Circus adv. on bldg. John Robinson's - Renovo, Pa.

Children of the early 1900s enjoy outdoor winter activities in this postcard. Television and computers have almost made sled riding a thing of the past in today's world. These children are using both bobsleds and regular sleds. John Robinson's 10 big show circus is advertised on the building for Renovo on June 1. (Potter County Historical Society.)

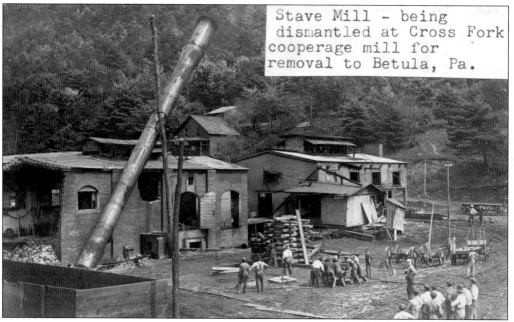

Stave Mill - being dismantled at Cross Fork cooperage mill for removal to Betula, Pa.

The Pennsylvania Stave Company built this mill in 1897 about the same time the big sawmill was constructed. It harvested timber off of Lackawanna Lumber Company lands for use in its mill. After logging operations ceased in the Cross Fork area, the mill was dismantled and moved to Betula. (Potter County Historical Society.)

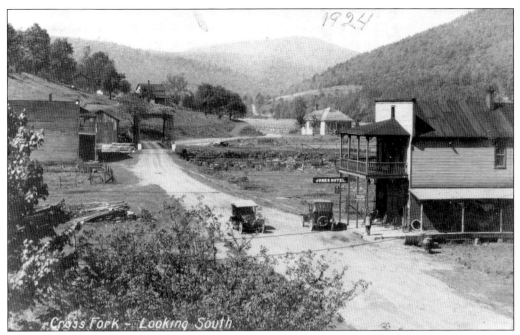

Jone's Hotel is seen in this 1924 view. Cross Fork has disappeared. The new one-room school that was said to be the epitome of rural schools was constructed in 1917. It is shown in the center background. The hills on each side of Kettle Creek Valley make up the rest of the picture. (Potter County Historical Society.)

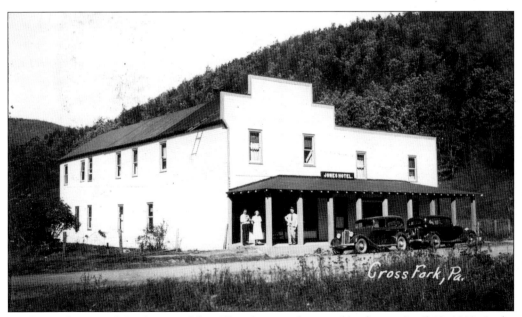

Jone's Hotel survived the demise of the village but was destroyed by fire on April 12, 1960. At the time of the fire, the hotel also housed the post office. A new post office has been located at what was the corner of Main Street and Lackawanna Avenue. (Potter County Historical Society.)

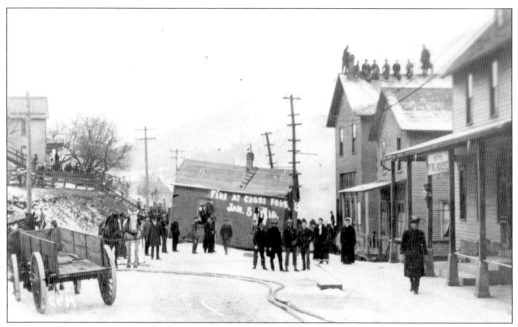

This fire on January 5, 1910, is one more reason the insurance companies started to refuse payment on fire policies and would not issue any new ones. As seen in the picture, the large number of men fighting the fire was probably due to their unemployment, leaving them with much idle time. (Potter County Historical Society.)

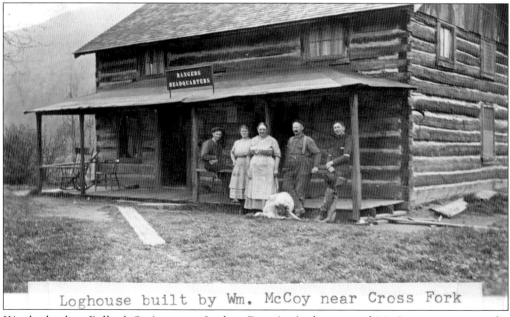

Kinckerbocker, Pollard, Springsteen, Jordan, Francis, Anderson, and McCoy were among the families that lived near Cross Fork before the big mill was established. Several log homes remain from the early period. William McCoy built the above home that remained in the family for several generations and later served as a ranger station. (Potter County Historical Society.)

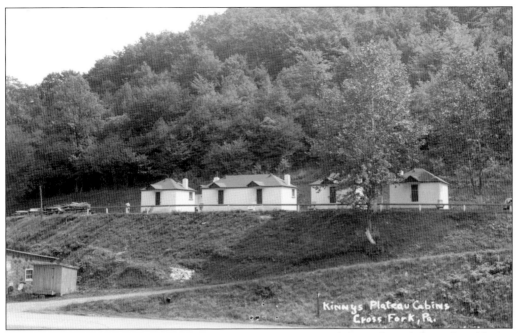

The population of Cross Fork disappeared after the closing of the mills and the railroad being taken up. As the American people became more mobile after the Depression and World War II, a few residents began to develop tourist facilities. One of these was Harry Kinney, who had a bar, a store, and a motel. The buildings shown were located on the site of the former high school.

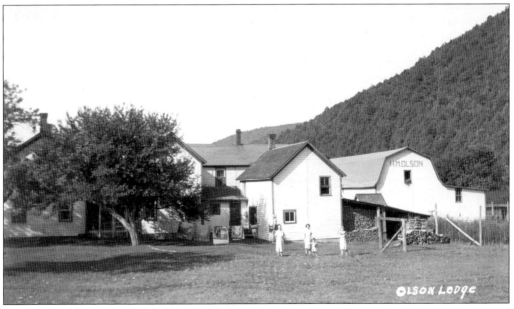

Martin and Hermania Olson and their children stayed on their farm near Oleona when most of the people from Ole Bull's colony left the state. Martin was killed in a logging accident in 1854. In later years, it was operated by Henry and Ida Olson as Olson's Lodge and catered to hunters and fishermen in addition to local travelers. Today it is operated as a bed-and-breakfast.

Ole Bull was a world famous Norwegian violinist who also delved into politics. He objected to the Swedish king being king of Norway. He was not successful at making changes at home, so he purchased land on Kettle Creek and established a colony in 1852. Due to reservations in the deed, the land was sold back to the former owner, and after a year, most of the colonists moved west.

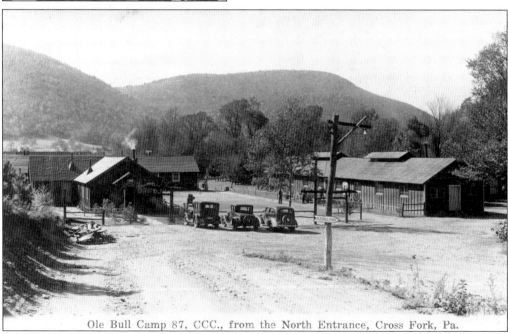

Ole Bull Camp 87, CCC., from the North Entrance, Cross Fork, Pa.

This is the Ole Bull Civilian Conservation Corps Camp S-87. Tents were used for living quarters until the land could be cleared and leveled in preparation for the construction of the permanent buildings. The first permanent building was the mess hall, completed in August 1935. This camp was located at the south end of where Ole Bull State Park is today.

Seven

SHINGLEHOUSE

Shinglehouse, originally known as Five-Mile Corners, received its unique name from a log cabin entirely covered with hand-hewn shingles that was built in 1806 by a Frenchman named M. Generet. It was located a little south of the present location of Shinglehouse. It was first a part of Eulalia Township and later it became Sharon Township when it was organized in 1828. In 1901, it was incorporated as a borough. In 1816, the first mail route from Jersey Shore, Pennsylvania, to Olean, New York, went through Shinglehouse.

Lumbering and farming were the only occupations for the pioneers who came to settle the Oswayo Valley. By the 1830s, there were at least seven mills in the Shinglehouse area.

The first school was built in 1837 at the end of Oswayo Street. In 1848, a second one was built on Honeoye Street.

E. A. Perkins built the Shinglehouse gristmill in 1875. It was located next to his sawmill. A. A. Mulkin and Thomas Cary operated a cigar factory in 1887. There were a number of blacksmiths throughout the town at this time. A cheese factory was started in 1893 and became quite famous for its Shinglehouse cheese.

One of the things that helped Shinglehouse move forward was the arrival of the New York and Pennsylvania Railroad. The first passenger train arrived in town October 29, 1900. Then the Palmer Window Glass Plant was built and a new town came into being. With the addition of these two industries, Shinglehouse now had a "downtown" and an "uptown." The town doubled in area and population within two years.

The glass plant opened on January 2, 1902. It employed around 200 men with a weekly payroll of $4,500. It took 32 gas wells to supply the plant and the domestic use in the town. The Palmers went bankrupt in 1911, and it became the Empire Glass Company. Then it was sold to Interstate Window Glass Company, but because machines for blowing glass had been perfected, the plant closed for good in 1921.

The New York and Pennsylvania Railroad and the Olean Street Railway Company brought people into Shinglehouse to work in the big glass plant. The Olean Street Railway Company was an electric trolley line that connected Shinglehouse with Olean, New York, for 25 years until the automobile and improved roads came along.

Another large industry that came to Shinglehouse was the Elk Flint Bottle Plant, which started business in 1904. The plant employed about 200 men and boys on two nine-hour shifts. It was in operation for about 15 years.

Today Shinglehouse is a quiet country town in the northern part of Potter County that supplies part of the workforce for Olean, New York.

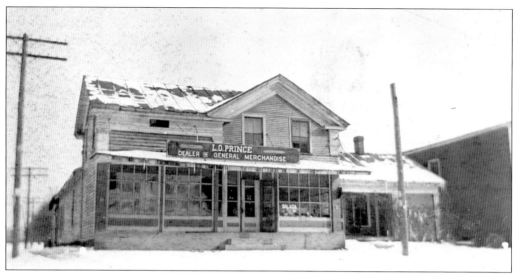

This is the Loren O. Prince general store. In later years, this store was known as Jones and Newton. The building stood for almost 150 years before being torn down. A door on the back of the building was dented by a baseball being thrown against it. The locals believe it was done by Fielder Jones, who later played for the Chicago White Sox.

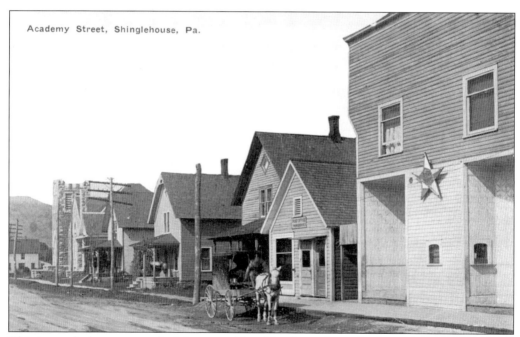

This is a real-photo postcard of the west side of Academy Street in the early 1900s. From left to right are the First Baptist Church, a number of homes, and a horse-and-buggy parked in front of the post office. The large building on the right was the Star Theatre that operated for 50 years.

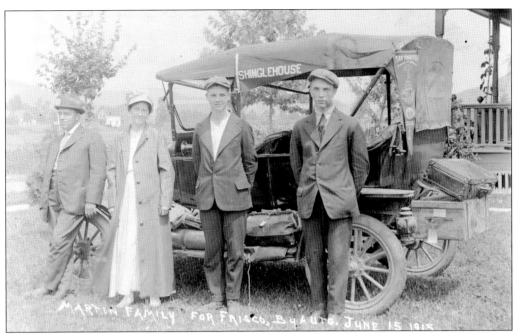

In 1915, *Motor* magazine offered a silver Tiffany metal to anyone completing a highway trip on the new Lincoln Highway from New York to California. The W. W. Martin family left Shinglehouse in their Ford on June 15, 1915, and arrived in Los Angeles on August 5, 1915. They were the 40th of 64 winners in 1915.

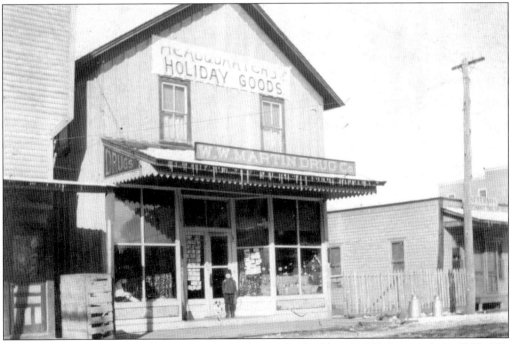

Pictured is the drugstore of W. W. Martin who made the Lincoln Highway trip in 1915. His drugstore was located on Academy Street. The building is still standing today and is occupied by the office of Dr. Dilbagh Singh.

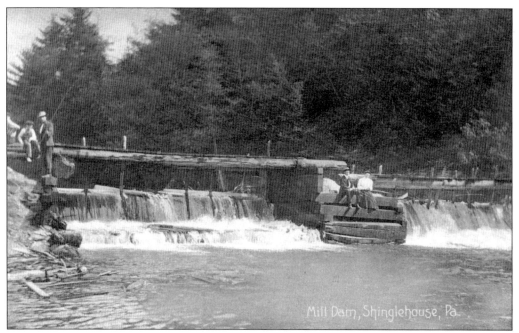

Like other early Potter County towns, the residents of Shinglehouse also used waterpower to operate their mills. This dam served the E. A. Perkins sawmill and gristmill near Oswayo Street along the creek. Current historians think either Perkin's father or grandfather may have built the dam.

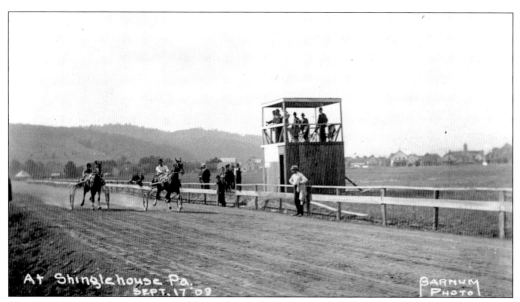

Harness racing was very popular in Shinglehouse from about 1905 until 1912. A new track was built in 1909, but it failed in a few years. The grandstand for the racetrack was located on the present site of the Oswayo Valley High School. This photograph was taken on September 17, 1909.

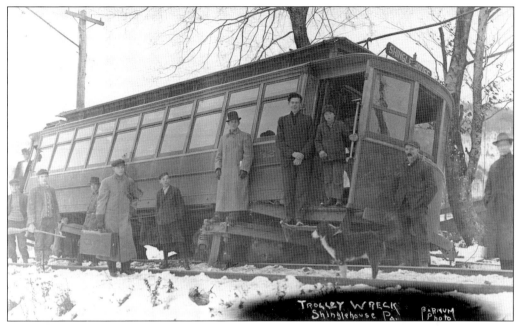

A wreck on the Olean Street Railway Company's trolley line between Bradford and Shinglehouse and Bolivar and Olean, New York, is shown in this real-photo postcard. The trolley line opened in 1902 and was shut down and sold at a sheriff's sale in March 1927. This was the only electric railroad to ever enter Potter County.

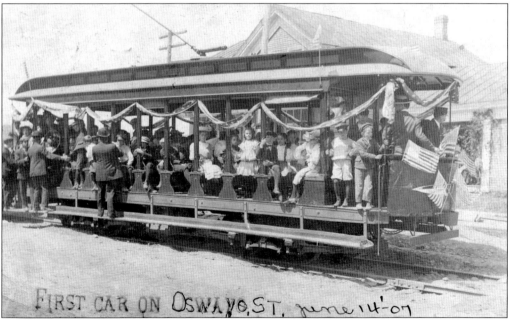

This postcard celebrates the opening of the Oswayo Street extension of the trolley line. A memorable event during the building of this extension occurred in 1905 where it crossed the New York and Pennsylvania Railroad. The railroad company put on a public display of objection to crossing their tracks, but the trolley company won out, and the crossing was installed that same day with the strong support of local citizens.

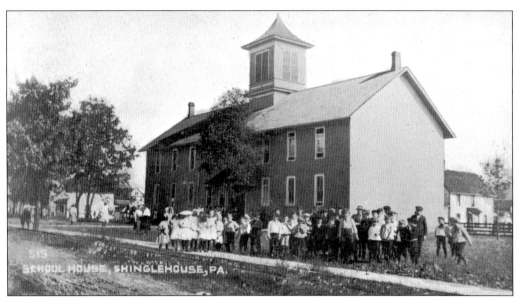

This wooden schoolhouse marked the end of Academy Street. It was purchased by the IOOF and moved across the street when the redbrick schoolhouse was built. In addition to being used by the IOOF and Rebekah's, it was used again as a school in the 1930s and 1940s for girls' home economics and boys' shop classes. It is currently an apartment house.

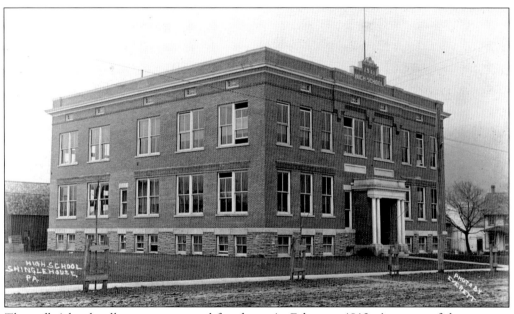

The redbrick schoolhouse was opened for classes in February 1912. As many of the country schools did not have high school classes, they came into town to attend this school. After a new high school was completed in 1954, this school was used as an elementary school. It was demolished in 1984.

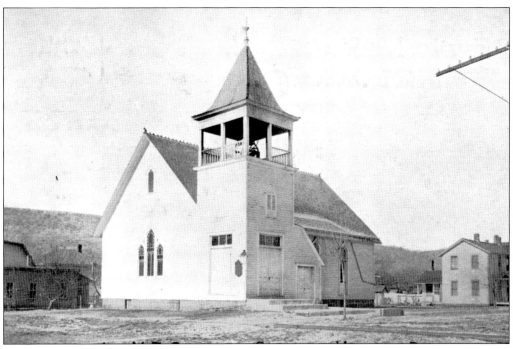

The Methodist Episcopal Church was incorporated in November 1885, but it was not until October 11, 1893, that the foundations of the building were laid. When completed, the church steeple contained an 800-pound bell. In 1963, a kindergarten and Sunday school annex was added on the back side.

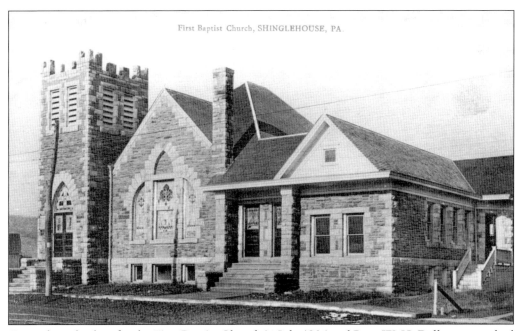

Ground was broken for the First Baptist Church in July 1906 and Rev. W. H. Dallman preached the first sermon on January 19, 1908, at union services. The beautiful stone building cost $14,000 to erect. It was the first public building in town to have electric lights.

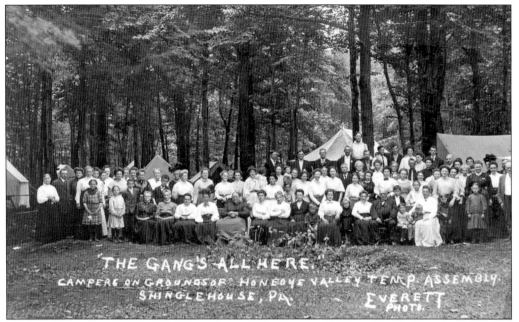

The Honeoye Valley Temperance Assembly was founded in the early 1900s on the A. F. Smith farm near the New York State line. It came to Shinglehouse a short time later. At Shinglehouse, its meetings were held the last week of August with members sleeping in tents. They enjoyed varied types of programs all week and had hack service take them to the railroad, hotels, and trolley stops.

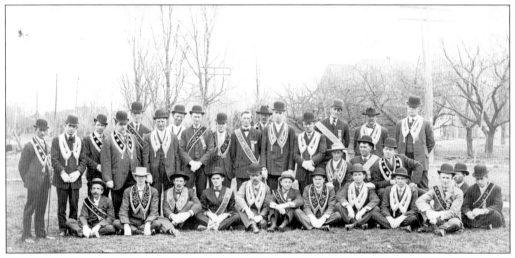

This is a rare real-photo postcard depicting the membership of the IOOF lodge No. 598 of Shinglehouse in dress regalia. The 10th person in the back row who is without a hat is identified as Ed Dodd.

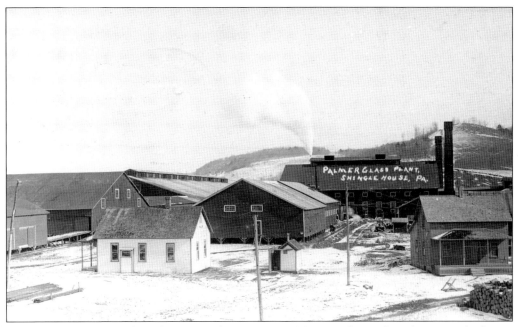

The Palmer Window Glass Plant opened in January 1902. It was located on the east end of town overlooking the Oswayo Valley. It employed about 200 men and boys at full production. It was reported that over a million board feet of hemlock lumber was used in the construction of the massive plant. When built, it was one of the largest glass plants in the world.

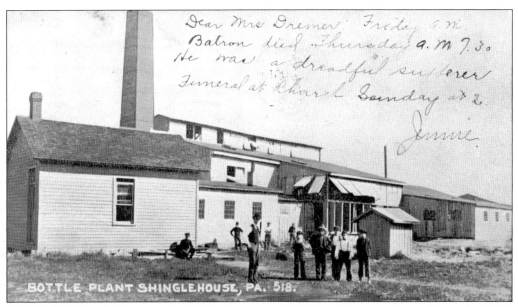

The Elk Flint Bottle Company built this plant around 1904 on five acres donated from the C. R. Nichols farm. It was known as an eight-ring tank and employed 32 glass blowers. In total, the company employed about 200 people. The business, located on Second Street, having been sold several times, operated for about 15 years and was torn down in 1919. A silk mill was later built on this site.

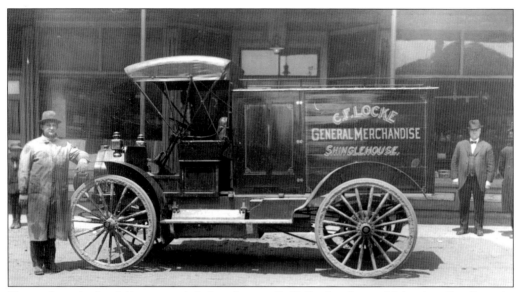

Shown here is the delivery truck belonging to C. F. Locke General Merchandise Store in Shinglehouse. An old view of a delivery vehicle such as this is very hard to find. A general store in the early 1900s handled anything one could imagine the population of the area needed in everyday life.

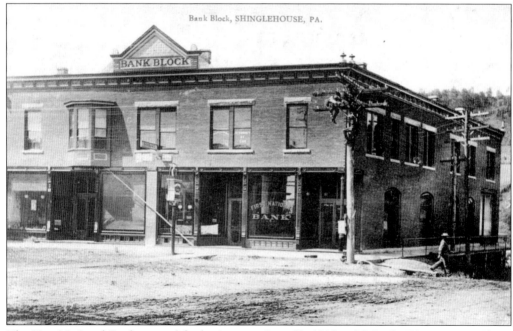

The First National Bank opened for business on June 10, 1903, with L. C. Kinner as president. The bank has continuously operated from this site except for a number of months after the fire of March 2, 1926, which destroyed a large number of businesses and apartments.

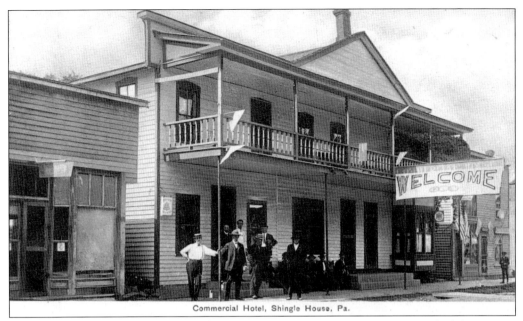

Commercial Hotel, Shingle House, Pa.

The IOOF lodge No. 598 of Shinglehouse may have been having some sort of celebration, as the welcome sign on the front of the Commercial House Hotel suggests. The hotel opened in July 1901, and the building is still standing today. It is located on Oswayo Street along the creek. The Masonic lodge is currently using this building.

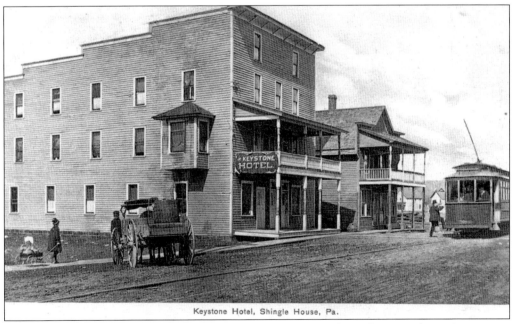

Keystone Hotel, Shingle House, Pa.

The Keystone Hotel, owned by W. P. Wlykoff and C. F. Plaisted on Academy Street, was opened in May 1902 and burned in September of the same year. It was immediately rebuilt with 23 sleeping rooms.

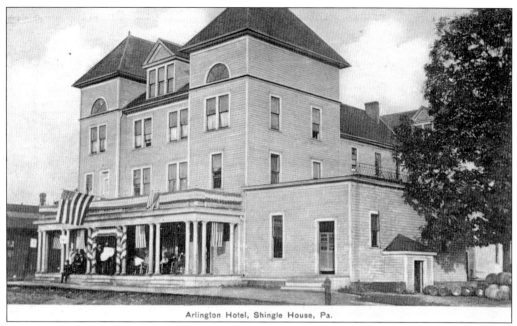

Arlington Hotel, Shingle House, Pa.

The Arlington Hotel was a very impressive four-story building and was the tallest in town. It was located near the new railroad station and built not too long after the railroad came to town. After a fire in 1910 burned off the top of the building the fourth floor was not replaced and only a new roof was constructed.

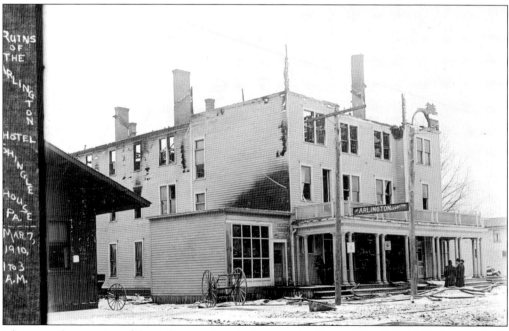

These are the remains of the Arlington Hotel after a major fire on March 7, 1910. It was rebuilt with only three floors after the fire instead of the original four floors. Notice the fire-hose cart from the Elk Flint Bottle Company at the left corner of the building. The loss was estimated to be around $25,000.

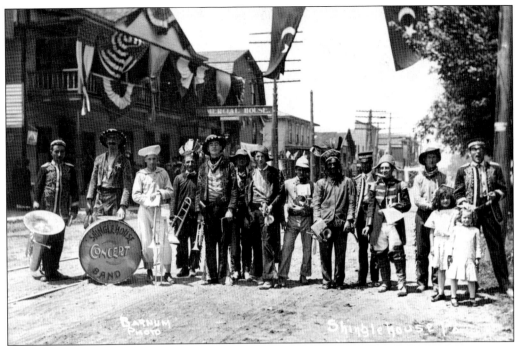

This is a real-photo postcard of the Kitchen Band from Shinglehouse on July 4, 1910. The Commercial House Hotel, located on Oswayo Street, is dressed in bunting and can be seen behind the band. A holiday parade was most likely the occasion for this photograph opportunity.

Like most towns in Potter County, Shinglehouse had a band during the early part of the 20th century. This picture of its band was taken at the Grange picnic while at Turtle Point. Turtle Point is north of Port Allegany in McKean County.

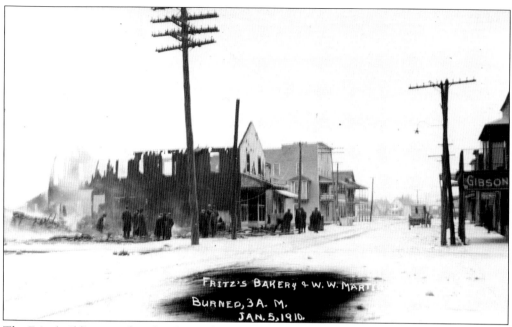

The Fritz building was found to be on fire about 2:30 a.m. on January 5, 1910. By the time the alarm sounded, a strong wind had already fueled the fire in such a way that the Fritz Bakery and the nearby W. W. Martin Drug Store burned to the ground within an hour.

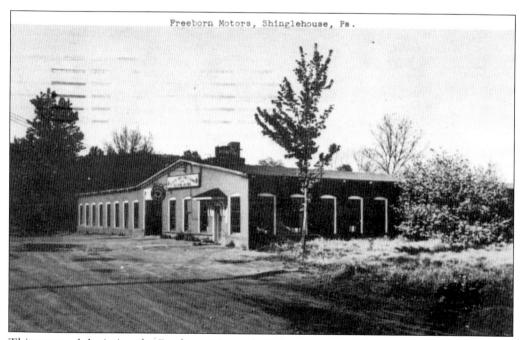

This postcard depicting the Freeborn Motors building appears to have been taken about 1958. Originally, this building was used as a hose or silk mill. It is still standing across from the present IGA Store on Mill Street.

Eight

Germania

Germania is located in present-day Abbot Township and was settled in the mid-1850s. The township was established in 1852 when Ole Bull settled at New Bergen and the assessment list for 1853 counted 58 taxpayers. In 1860, the first township census listed 377 residents. The township reached its population peak in 1890 with 825 residents.

The Germania settlement began as a scheme to establish a colony for Germans who had fled the persecution of their homeland. To accomplish this, the Pennsylvania Land and Farm Association was formed. Originally they were to purchase about 90,000 acres and divided it into 3,500 shares. Each shareholder was to receive a farm of 25 acres for improvement. They also received a village lot in their contract to lay out a new town. The price for each share was $200. They were required to pay $10 in advance and $5 per month for the balance. The advanced group that came to clear the land had a very trying time but after several months, had completed a cabin. They suffered not only from the cold but also from a lack of food. They made it through that first winter by building a sawmill, hotel, and store.

The first settlers traveled to Germania by way of the Jersey Shore and Coudersport turnpike, which was a crudely cut trail through the forest. In the late 1850s and early 1860s when the settlers arrived, they did not find what they expected, as the steep, forest-covered slopes were not the rolling hills and flat land they thought they had purchased. Because they had no resources remaining, they had no choice but to stay.

In spite of the early settler's difficulties, Germania grew into a village of considerable size. For a number of years, it had the only firefighting equipment in the county. The Schwarzenbach Brewery opened and continued in Germania until it was moved to Galeton in 1902. In 1876, the village supported two hotels, five retail stores, meat markets, shoe stores, a barbershop, and a brewery.

A Lutheran church was built in 1867 and used by the Lutherans and Catholics alike until the Catholics completed their own church in 1874.

The large lumber companies cut the vast forests around the village.

Germania still remains a quaint village with Old World picturesqueness that was established by its early settlers. Some of its surrounding hills are still farmed by descendents of those German refugees of more than a century ago. A hotel, a store, and a few small businesses still remain in operation today.

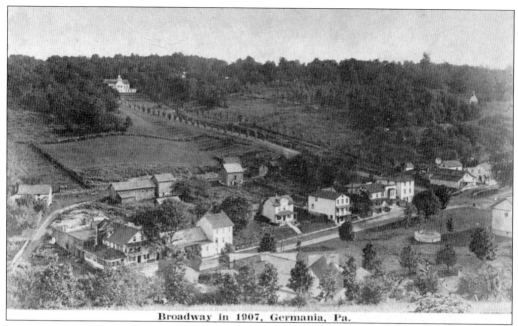

Broadway in 1907, Germania, Pa.

This is a 1907 postcard view of Broadway Street in Germania. The Schwarzenbach Brewery is on the left followed by the cheese factory, some private homes, and a shoe shop. On the hill at the top of the picture is the Schuetzen Verein Clubhouse, which was organized by Dr. Charles Meine in 1894.

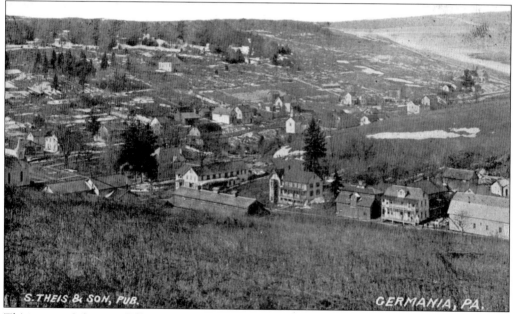

This postcard shows a different view of the center of Germania and the surrounding hills. The photograph was taken from behind the Germania Hotel. Some of the buildings visible are the Lutheran church, the Germania Store, Harold Beacher's garage, the Cottage Hotel, the Germania Hotel, and livery barn. At the top of the picture is the white schoolhouse on the hill.

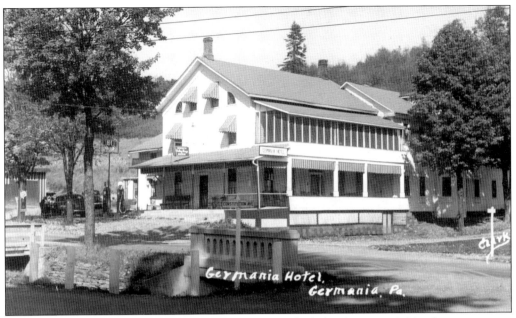

The Germania Hotel was built in 1856 and served as the hub of town activities for many years. Today many people remember the antiques that decorated the walls of the hotel until it changed hands in 1987. The hotel had many owners over the years, and although its appearance has changed, it is still in operation today.

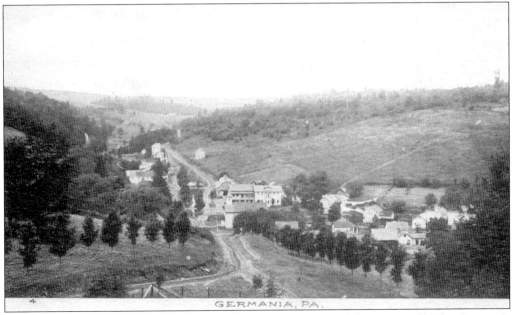

This early-1900s photograph appears to have been taken from Club House Hill. The Germania Hotel is in the center with homes and businesses on either side. At the time, the large trees had been harvested from the surrounding hills. Behind the hotel is the road leading to Galeton. The road in the foreground to the left leads to Cross Fork.

The St. Matthaeus Lutheran Church in Germania went under construction in 1867 and the first confirmation class was held in 1868. The church is now in its second century of serving the community as a place of worship and fellowship, along with marriages and funerals.

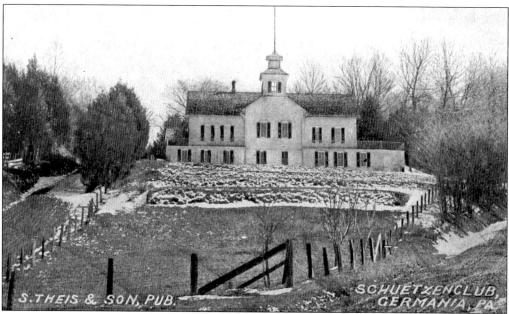

Schuetzen Verein was formed in 1894 with only four members. The membership had increased to 125 four years later. The clubhouse was erected between the vee of two roads, today known as Club House Hill. The club had an outside dance platform and bowling alleys for use by its members. It was a popular gathering place for relaxation and entertainment by the beginning of the 20th century.

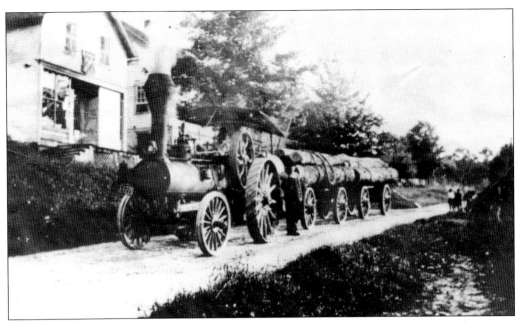

This is Frank Cizek's traction engine pulling two loads of logs to the heading factory in Germania. William Knight is on the engine and John Cizek is standing nearby. It was possible to make two trips a day with a top speed of three miles per hour downgrade. It was powered by a 1917 Peerless engine.

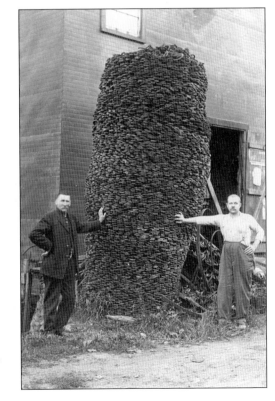

A. Zoerb and Henry Brecher are pictured in front of Brecher's pile of used horseshoes. This photograph was most likely taken between 1912 and 1915. Brecher operated a blacksmith and wagon shop in Germania for many years. It must have taken a lot of horses to produce this amount of used shoes. The horseshoes likely were sold for scrap in later years.

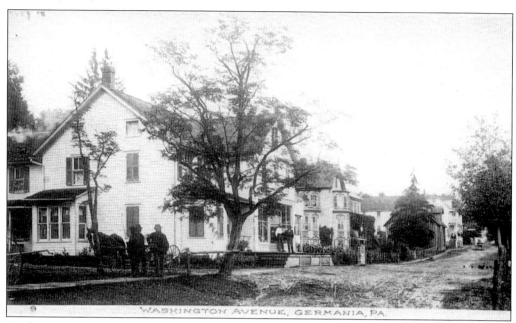

Washington Avenue in Germania ran from Route 144 in a southeasterly direction until it joined with Broadway. There were a number of fine-looking homes lining the street, along with the Odd Fellows hall and a theater and dance hall.

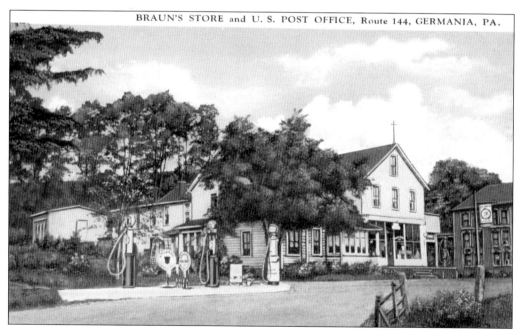

Otto Braun moved the Germania Store from the basement of the hotel to this building. In 1921, Herman Braun started selling Atlantic gasoline at the store. The business was in the Braun family for many years, with Milton Braun being the last to operate it before selling to Russ Keith in 1975. It has had a number of owners since that time and still serves the residents of the area today.

Nine

GOLD AND ULYSSES

Gold, a small crossroads town, was founded about 1857. The lumbering days brought boom times to the little settlement, and it grew rapidly. In 1881, it received a post office. Asa Raymond, a member of Gold's founding family, became the first postmaster. In its early days, it had a small tub factory and small tannery. They both flourished until they moved to the Ulysses area in 1883. A hotel was built in 1888 and saw several owners until finally burning to the ground. The owner at the time was jailed for arson. By 1898, Gold had 29 houses, one hotel, one blacksmith, three stores, a large schoolhouse, a depot, a water tank, and 135 inhabitants. A flouring mill and cheese factory also operated there for many years. Presently a store is still in operation by the crossroads and a church is still standing.

Ulysses, or Lewisville, as it was known in its early days, had its first permanent settler in 1827 named John Hackett. The town continued to grow, and from about 1833 to 1848, it began the position it long occupied as the chief town in northern Potter County. As settlement increased, shops and mills were constructed, making the long trips to have flour ground a thing of the past. There was a boot and shoe factory that employed 50 men. There were a number of hotels built through the years, some for the convenience of the railroad passengers. Although there were public schools, an academic school was erected in 1859. It was known as the Octagon Academy because of its shape. A number of larger public schools followed as the population increased. Churches were built through the years and the borough was incorporated on September 23, 1869, as the second borough in Potter County. Surrounding the town was a large farming community, and agriculture became a chief industry of the area. When incorporated, there were two churches, two hotels, two blacksmith shops, a harness shop, five stores, a sawmill, an academy, a common school, and about 35 homes.

In 1895, Balcolm and Lay built a butter dish factory at Ulysses. They also made thin wooden containers used by grocers for butter, sausage, and other like products. The factory was closed in November 1908.

The town was served by two railroads for a while, but after the lumbering days and the automobile replaced train travel, the railroads operated at a deficit. In 1925, the Coudersport and Port Allegany Railroad (C&PA) discontinued its operations, and in 1933, the New York Central Railroad did the same. Today Ulysses is a nice, quiet little community still surrounded by farms and forests.

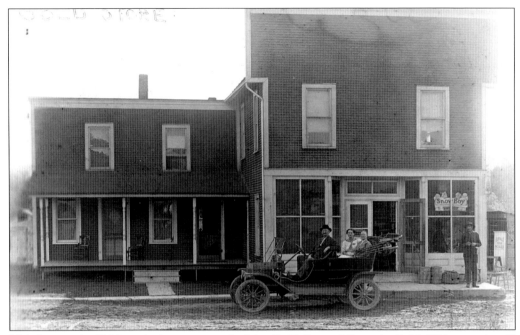

This is an early-1900s real-photo postcard of the Gold General Store in Gold. This store is still in operation today, although the appearance of the front of the building has changed somewhat over the years. The people in the picture are not identified. This building also housed the post office for the Gold area. The car appears to be from the 1910 to 1915 era.

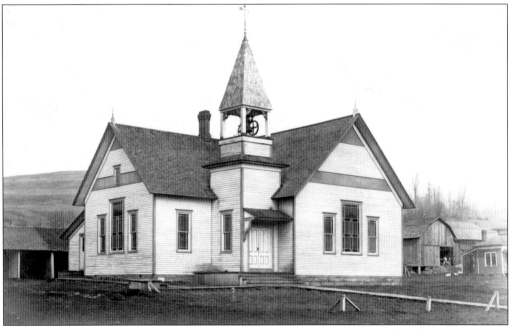

In 1898, the town residents decided they needed a church. They set about building one on land donated by Asa Raymond, and the new church was dedicated in September 1899. Until 1966, it was a union church for both the Baptist and Methodist congregations. Then it changed to the First Baptist Church of Gold. In recent years, a kitchen was added to the back of the building.

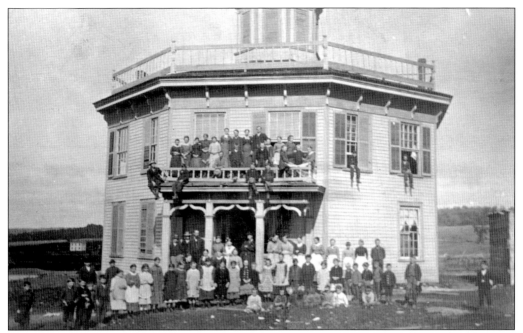

In 1859, an academic school was erected in Lewisville, now Ulysses, by popular subscription. With the assistance of donations and the proceeds from an oyster supper and square dance, the mortgage was eliminated. The Octagon Academy had Prof. Joseph H. Cooper, a graduate of Yale College, for its first professor. After many years of service, it was torn down in 1897.

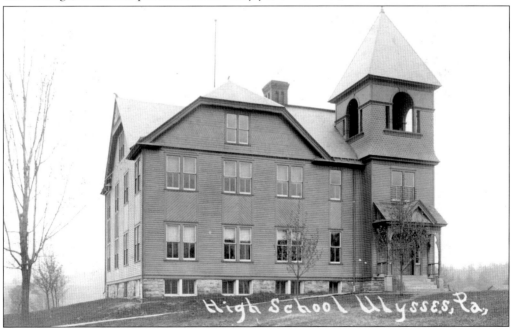

The home of O. A. Lewis was used for the first school in Ulysses with 20 students in 1834. In 1845, Elias Cady was commissioned to build six frame schoolhouses in the township. These six schools served the township for almost 100 years. The school depicted on this card was built in 1897 and replaced the Octagon Academy.

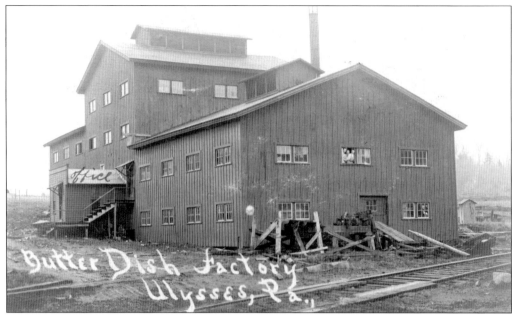

This is a real-photo postcard of the Balcolm and Lay Butter Dish Factory in Ulysses. The factory was built in 1895 and operated until 1908. It produced butter dishes and thin wooden containers used for butter and sausage by grocers and butchers. In later years after operations had ceased, the building was used as a milk station by the proprietors of the condensery at Coudersport.

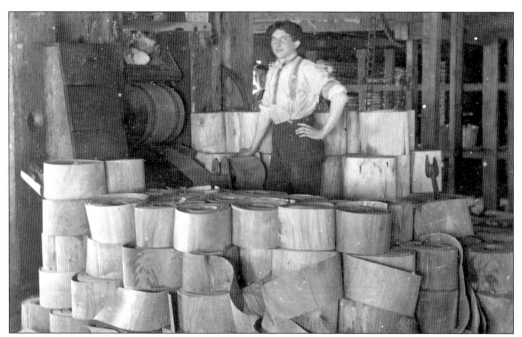

Dairy farmers produced milk, which, before speedy transportation, was difficult to get to the markets, so rural farmers depended on local cheese and butter processors to provide a marketable product. This picture of the interior of the butter dish factory shows the bolts of heavy veneer used to make cheese or butter containers. (Potter County Historical Society.)

Ulysses became the early center of agriculture for northern Potter County, and John Morrison was one of three blacksmiths who kept the farmers' equipment in working order. Morrison is the man standing on the right side of the picture. Note the large amount of horseshoes hanging from the ceiling that were probably made in advance for future needs. (Potter County Historical Society.)

This trestle carried the Fall Brook Railroad over the public road between Ulysses and Harrison Valley. In the early 20th century, the New York Central and Hudson Valley Railroad acquired the Fall Brook Railroad, which served the Cowanesque Valley. The borough of Ulysses was also connected with Coudersport by the Coudersport and Port Allegany Railroad for over four decades.

Brookland, originally called Cushingville, was an early sawmill and farming community in Ulysses township. Henry Hatch Dent moved from Coudersport and built the first mansion near this site. It was named Brookland. It burned and the land was sold to John Stone, who constructed this building, which is now owned by the Wingo family. (Potter County Historical Society.)

After the Potter County Farm Bureau was organized in 1916, farmers began to organize according to their specialties, such as sheep, cattle, potatoes, and so on. H. Lehman may have been one of those who formed the cooperative in 1920. At the time, there were 40 growers in the organization.

Ten

Other Towns and Villages

What are considered today to be small towns, villages, and hamlets throughout Potter County were very busy and sometimes rather large communities during the logging and railroad era. They all had many places of employment that attracted people to the area to live and raise their families. Although most of the people left these towns and villages after the boom times were over, enough stayed and created a number of the communities that exist today. Other areas are ghost towns, with only a few houses or a small store along the road as a reminder of what used to be in earlier times.

Harrison Valley Township, which contains both Harrison Valley and Mills, came into being on February 6, 1823, as the third township organized in the county after Eulalia and Roulette. Some historians think that settlement started around 1810 or only a short time later.

Between 1880 and 1900, Harrison Valley experienced its most active business period and attained its largest population of almost 1,200 residents. The bark from hemlock timber being cut for sawmills was used at a tannery built in 1882 by the Walter Horton Company. It was closed in 1922 and torn down in 1923, along with its tenement houses. In the fall of 1883, the Fall Brook Railroad came through the township and served the tannery, the mills, and other businesses until it discontinued operations in 1932.

In 1916, Jessie Van Dusen started a children's home that is still in operation today.

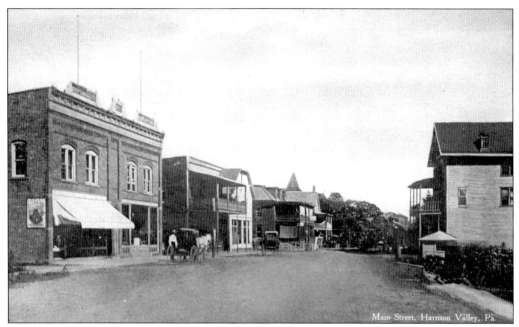

Harrison Valley, with its hotels, stores, and other businesses, was one of the busiest towns in Potter County. Harrison Township led Potter County's population during the 19th century. The pictured businesses served as the shopping center for Harrison Township and the Upper Cowanesque Valley.

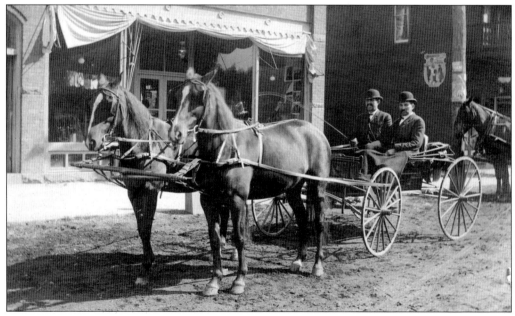

Stone family members sit in their buggy in front of their hardware store in Harrison Valley in this real-photo postcard. Pictured are Adelbert Stone, father of Elberta; and Elbert Stone, father of Huber, Harold, Blanch, and Florance. This picture shows a popular mode of transportation during the early 1900s. These two gentlemen also owned and operated the Opera House Hall in Harrison Valley.

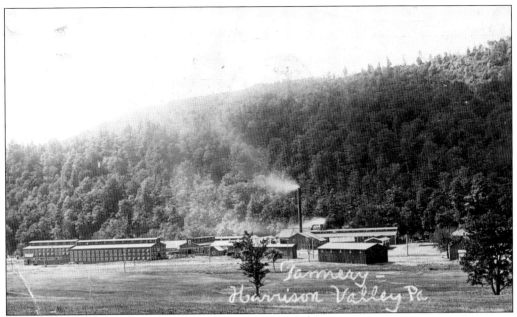

Harrison Valley had one of the seven tanneries located in Potter County. As large quantities of hemlock lumber were being cut in the local mills, a tannery was built in 1882 to make use of the bark to manufacture sole leather. The tannery quickly became a large employer. It discontinued operations in 1922 and was dismantled and salvaged the following year. (Potter County Historical Society.)

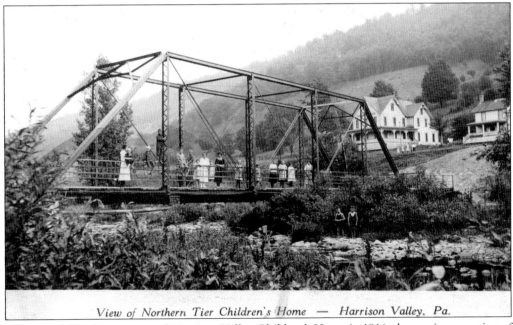

View of Northern Tier Children's Home — Harrison Valley, Pa.

When Jessie Van Dusen opened Harrison Valley Children's Home in 1916, she was in possession of two children and a bushel of potatoes and in need of a lot of prayers. With local help, she obtained a house that she and a few others remodeled. The home was twice destroyed by fire, first in 1927 and again in 1940. After the 1940 fire, the building at the present site was constructed.

Mineral Well — Harrison Valley, Pa.

For those seeking relief from many maladies, mineral water was the cure-all at the dawn of the 20th century. It was somewhat better than the "one for a man, two for a horse" of the patient medicine era. After this well was discovered in 1901, a bottling works was put into operation. Hotels in the area benefited from those using the water for their relief.

Price List of Artesia Mineral Water.

Price including package at Spring

	Price.	Rebate.
Case 12 Half Gallon Bottles - - - -	$2.50	$1.25
Five Gallon Glass Demijohn - - -	$1.50	$.75
Three Gallon Glass Demijohn - - - -	$1.25	$.50
Two Gallon Glass Demijohn - - - -	$1.00	$.35

Rebate is only allowed upon return of containers in good condition from original purchaser.

Look out for imitations—Buy only in original packages.

Harrison Valley Mineral Water Company.
Harrison Valley, Penn'a., U. S. A.

The mineral well water was bottled by local residents who purchased an empty plant for their purpose and shipped the bottled water all over the east. The prices were on the back of an advertising postcard.

In its early days, most activity in Harrison Valley took place in the area pictured on this card. The school and railroad station were meeting places and the Valley Milling Company employed many people from the town and surrounding area.

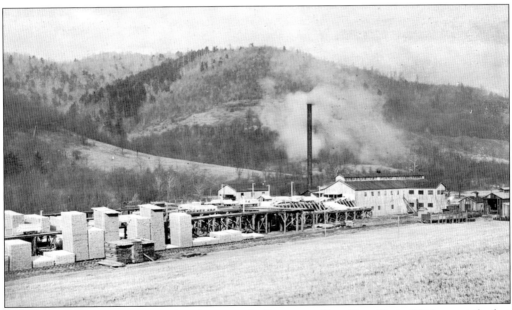

The Central Pennsylvania Lumber Company built a sawmill at Costello in 1916 to cut the last large stand of virgin timber in Potter County. The mill only operated about four years and closed at the end of the year in 1920 when the last great track of timber was exhausted. This picture was probably taken shortly after the mill went into operation, as the lumberyard was still small.

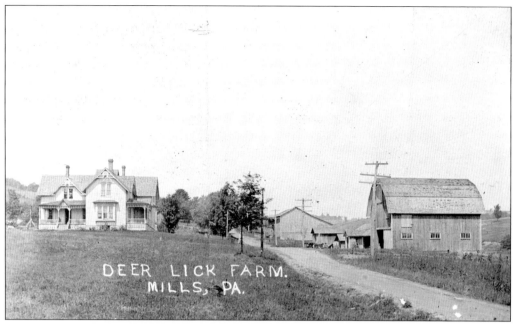

The early settler's farms were usually small with only a few acres cleared of timber, and their cattle grazed in the forests due to the lack of fodder. As the farms grew larger, so did the dairy herds and their surplus milk. The surplus milk was delivered to area cheese factories. This is a real-photo view of the Deer Lick Farm near Mills.

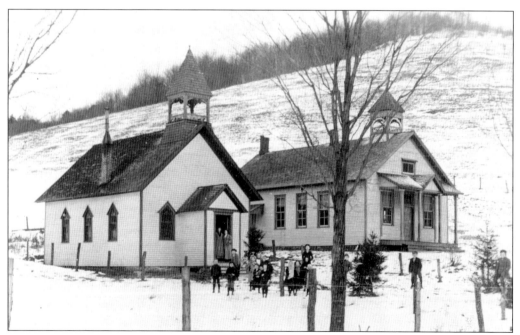

Mina was where the Lackawanna Lumber Company had its first Potter County mill. The school and church were across the road that ran north of the town. After the last of the timber was cut in 1912, the mills closed and the exodus of the residents began in earnest. (Potter County Historical Society.)

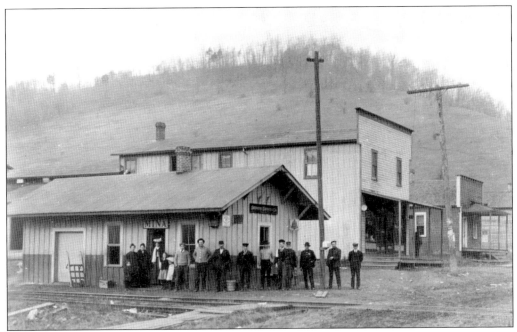

Mina was a booming lumber town from 1863 to 1912. The Mina railroad station, the store, and the lumber company office were located on Main Street. The town's sawmills were located southwest of these buildings. There was also a post office, a barbershop, a lodge hall, a dance hall, and a poolroom. (Potter County Historical Society.)

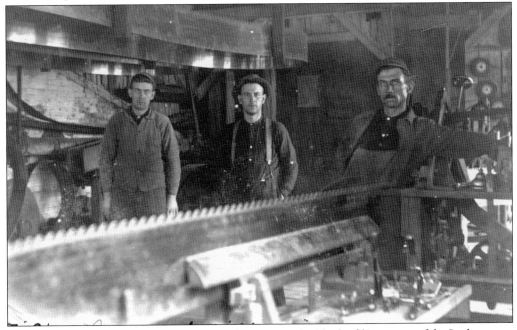

This real-photo postcard depicts an extremely rare view inside the filing room of the Lackawanna Lumber Company sawmill in the lumber boomtown of Mina. This card was posted from the Mina Post Office in 1910, but the picture was probably taken a few years earlier. This is a great view of the band saw–type blade used in this mill.

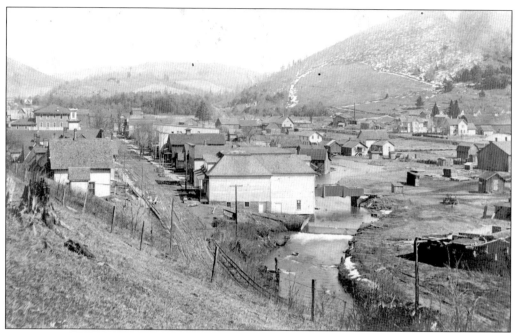

Some of the heaviest pine timber was found in the Oswayo Valley and its tributaries when the first settlers came to Potter County. *Oswayo* is a Native American word meaning "stream of big trees" or "stream of pines." This is a bird's-eye view of the town as it looked about 1907.

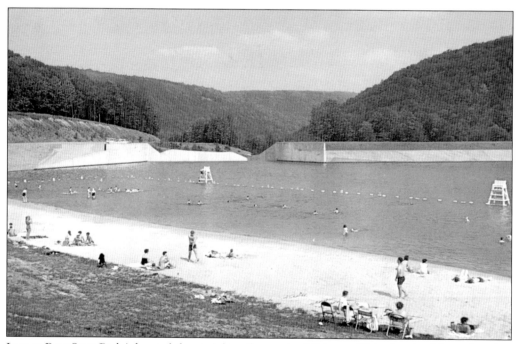

Lyman Run State Park is located about eight miles south of Galeton. This view is of the swimming beach with the dam in the background, and along with a campground (not pictured), it was always a very popular location for local residents and tourists alike. A new dam that was filled in the spring of 2008 replaced this one.

Bibliography

Beebe, Victor L. *History of Potter County, Pa.* Potter County Journal, 1934.

Germania . . . Our Heritage, 1855–1995. Germania, PA: Germania Book Committee, 1995.

Goodyear Hose Company, 1906–2006. Galeton, PA: Centennial Book Committee, 2006.

Potter County Historical Society. *Historical Sketches of Potter County, 1776–1976.* Coudersport, PA: Potter County Journal, 1976.

Kinney, Harry. *The Story of a Ghost Town, Part I & II.* Coudersport, PA: Potter-Leader Enterprise, 1980.

Nuschke, Marie Kathern. *The Dam That Could Not Break.* Coudersport, PA: Potter-Leader Enterprise, 1988.

Pippin, Bill. *Wood Hick, Pigs-Ear & Murphy.* Printed in the USA, 1976.

Shinglehouse Bicentennial, 1806–2006. Shinglehouse, PA: Shinglehouse Book Committee, 1969.

Taber, Thomas T. III. *The Goodyears: An Empire In the Hemlocks.* Williamsport, PA: Reed Hand Litho Company, 1971.

———. *Whining Saws and Squealing Flanges.* Williamsport, PA: Reed Hand Litho Company, 1972.

———. *Sunset along Susquehanna Waters.* Williamsport, PA: Reed Hand Litho Company, 1972.

Ulysses Area Centennial, 1869–1969. Ulysses, PA: Ulysses Historical Committee, 1969.

Across America, People are Discovering Something Wonderful. Their Heritage.

Arcadia Publishing is the leading local history publisher in the United States. With more than 3,000 titles in print and hundreds of new titles released every year, Arcadia has extensive specialized experience chronicling the history of communities and celebrating America's hidden stories, bringing to life the people, places, and events from the past. To discover the history of other communities across the nation, please visit:

www.arcadiapublishing.com

Customized search tools allow you to find regional history books about the town where you grew up, the cities where your friends and family live, the town where your parents met, or even that retirement spot you've been dreaming about.